SECRET
MATLOCK &
MATLOCK BATH

Richard Bradley

About the Author

Richard Bradley was born in Sheffield and raised at Oaker and Two Dales, attending South Darley and Highfields schools. He now lives in Sheffield with his partner Kate and two sons. He has written for publications including *Derbyshire Life, Best of British, My Kind of Town: Nostalgic Reflections of Bygone Sheffield, Record Collector, Picture Postcard Monthly* and the Caught by the River website. His first book, *Secret Chesterfield*, was released by Amberley in early 2018. His 2006 solo album (as The Pony Harvest) *An Individual Note: Of Sound, Music and Electronics* (largely recorded in Wensley) received BBC Radio 1 airplay, and as a musician he has collaborated with members of The Specials, Cabaret Voltaire, Can, Add N To (X) and I Monster. He is *not* Richard Bradley, the eminent archaeologist based at the University of Reading (although he does appreciate a good stone circle).

For Kate, Oscar and Leo

First published 2018

Amberley Publishing
The Hill, Stroud
Gloucestershire, GL5 4EP

www.amberley-books.com

Copyright © Richard Bradley, 2018

The right of Richard Bradley to be identified as the Author of this work has been asserted in accordance with the Copyrights, Designs and Patents Act 1988.

ISBN 978 1 4456 8336 2 (print)
ISBN 978 1 4456 8337 9 (ebook)

British Library Cataloguing in Publication Data.
A catalogue record for this book is available from the British Library.

Origination by Amberley Publishing.
Printed in Great Britain.

Contents

Introduction

I made my arrival into the world in the early hours of Boxing Day 1980 at Jessops Hospital, Sheffield, and after a week or so returned to what was to be my new home, on Will Shore's Lane in the tiny hamlet of Oaker (two different spellings of it exist – Oaker and Oker – we always employed the one with the 'a', so I'm sticking to it, and am backed up on that by the Ordnance Survey, who spell it likewise).

It was a largely self-contained world, and I grew up absorbed by the natural world of animals and birds that surrounded us. As a family we made the 2-mile journey into Matlock around once or twice a week. My childhood memories of the town in the 1980s include being taken to the playground of Hall Leys Park by my dad while my mum cooked the Sunday dinner; shopping trips to Fine Fare supermarket (at the time of writing Marks & Spencers), which had a central aisle of large see-through Perspex vats full of things like oats, lentils and flour that you scooped out into bags and weighed; Woolworths with its pick 'n' mix, chart singles on 7" and cassette and strange indoor garden centre sprouting off to the side; the trinkets and gewgaws lining the shelves of The Gift Box on Firs Parade; and trips to local fleapit cinema The Ritz (now the Maazi Indian restaurant) to watch films dissected by an interval halfway through where everyone diligently queued to buy an ice cream from the stall at the front, and preceded by a *Mr Magoo* short and low-budget adverts for local businesses featuring still photos and muffled voiceovers that sounded like they had been recorded with the microphone positioned underneath a carpet.

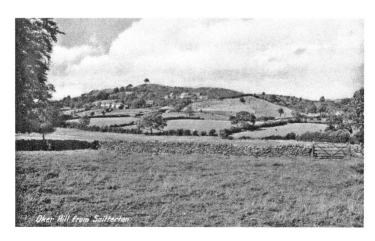

An old postcard view of Oaker Hill from Snitterton.

In 1992 I left the cosy confines of South Darley School along with the three other boys who constituted my year group and moved up to Highfields School in Matlock, a dual-site secondary school with premises towering strategically like fortresses on neighbouring hills above the town at Starkholmes and Lumsdale. It was a terrible shock to suddenly find myself one among over a thousand, instead of the fifty-two of us who were the total number of attendees of the little rural primary school. I did enjoy history lessons though, and after the promising start of receiving an 'A' in the subject in my GCSEs, chose to study it for A level, in a select class of six. Two of my contemporaries were to go on to study at that illustrious seat of learning, the University of Cambridge. I, however, having got a 'D' in my A level history exam, did not. Before you all go scuttling off for a refund, I can assure you I have put far more effort into researching this book than I did for my A levels...

It is a common human flaw not to fully appreciate what is on your front doorstep; as a teenager I considered Matlock oppressively dull and fled for the bright lights of nearby Sheffield. However, it turns out that there is more to Matlock and Matlock Bath than pick 'n' mix and *Mr Magoo* – much more. So whether you be dyed-in-the-wool local or one of the many tourists who pass through, I hope you will find something new and unexpected in this romp through the lesser-known aspects of the area's history, from prehistoric times to the present day.

Matlock Bank viewed from the slopes of Masson.

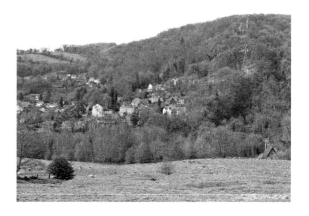

'Little Switzerland': Matlock Bath viewed from Starkholmes.

1. Water

Water is essential for life, an underappreciated fact in an era when most of us in the western world now turn on a tap to fill a kettle, draw a bath or water the garden plants without sparing a second thought about where our water is coming from. In a small hidden glade just off the busy B5056 road between Winster and Grangemill, unseen and unknown to most of the drivers who whizz past it every day, a small pipe emerges from out of the hillside offering a constant flow of water, which spills into a grate in the ground. This is the Shothouse Spring, and for a small handful of farmhouses on nearby Bonsall Moor it formed their main source of water supply (along with collection tanks) for domestic use until they were piped onto the Severn Trent mains supply at the astonishingly late date of the early 1990s. Even then, one of the elderly farm dwellers, Sam Raines of Bonsall Lane Farm, continued to rely on the natural water supply from the farm's tank over the new-fangled supply emanating from his taps. Geoff Lester, chairman of Winster Local History Group, informed me in early 2018, 'His sister Adelaide still lives at the farm (and probably still prefers water from their tank)'.

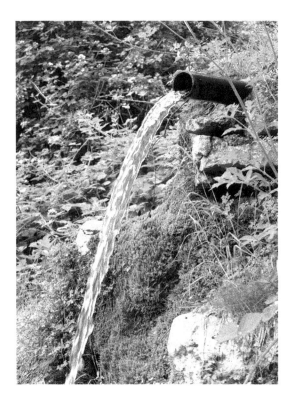

The Shothouse Spring, between Winster and Grangemill, a natural water supply.

While it is a common occurrence for the towns and villages we live in today to have developed around a reliable water source, in Matlock's case the element of water was responsible for the expansion of the town in a different way. In the mid-nineteenth century, largely at the instigation of John Smedley (although other contemporaries had previously begun to dabble), Matlock expanded as a hydrotherapy resort. The majority of the hydropathic establishments were located on Matlock Bank. Before they were built this was a sparsely populated rural hillside dotted with scattered farms. The hydros initially utilised the naturally occurring springs emanating from the gritstone of the Bank for their treatments, which included the Ascending Douche, back spouting and the gruesome-sounding bowel kneading.

While medicine and surgery have improved significantly since the mid-1800s and the modern reader may perhaps be sceptical regarding the effectiveness of hydrotherapy, it must be remembered that as a contemporary 'cure' it was possible to walk into a chemist's shop and buy cocaine, opium and heroin over the counter. By contrast with (legally) drugging yourself up to the eyeballs on Class A's, a package of rest and relaxation, hydrotherapy and healthy diet served up by the hydros in the picturesque surroundings of Matlock was a much gentler, and probably in many cases more beneficial, restorative aid.

DID YOU KNOW?

Until the late date of 1985 when it was finally disbanded, the village of Elton had its own 'Fire Party'. In the remoter Derbyshire villages, auxiliary units of firefighters made up of volunteer residents were established to tackle blazes until the actual fire brigade could arrive from the nearest station, in Elton's case Matlock – by the mid-1980s the response time to an emergency call was estimated to be twelve minutes. The fire box in Elton contained a hand siren, standpipe, turnkey, six hose reels, nozzle and list of hydrants. It was the last such surviving group in Derbyshire and is also believed to be the last one in England.

When hydrotherapy fell out of vogue it left Matlock littered with a number of large, grand and redundant buildings, which have been subsequently recycled for a number of uses including a former teacher training college, apartments and a care home. Smedley's, the largest and grandest of the hydros, now has the highest-profile second life as Derbyshire's County Offices, relocated from Derby in 1956. Council workers keep Derbyshire ticking over from their offices, which formerly were guest bedrooms or grand dining rooms, and the building retains traces of its original function, such as the wall-mounted marble drinking fountains located in a long corridor just off the main reception area where passing guests were previously able to imbibe the Matlock waters, or ornate covered shelters in the grounds. I came across an intriguing reference in Naylor's *Ancient Wells and Springs of Derbyshire* (1983) to a grotto that still existed in the Winter

Garden, the grand glasshouse formerly used for dancing to live orchestra in the hydro days. With the kind permission of county council staff, I arranged to view and photograph this little-seen grotto. Until recent years the Winter Garden was packed with desks, office partitions and council staff. However, when I visited in April 2018 the glasshouse was empty and looking forlorn as a consequence of a burst water main on Smedley Street a few years previously, which had flooded the premises. The grotto remained however, a wall of tufa (a variety of limestone that occurs locally, formerly much prized for use in Victorian rockeries) with vivid green ferns sprouting out of it. A doorway had been cut into the tufa as a portal to elsewhere in the council offices with a sign warning anyone above elf height to mind their head on the way through. The member of council staff who unpadlocked the room for me to view it told me that occasionally natural spring water still seeped into the base of the grotto and that 'we used to get frogs coming in it'. I'm willing to bet that no other county council in the land has previously had a frog-infested grotto in the offices of their transport department.

Lesser-known hydros were also established outside of the town centre at Darley Dale (the premises later became St Elphin's girls' boarding school, and in recent years the Audley luxury retirement village); Tansley (currently the Tansley House care home); and Winster, where the elegant Georgian mansion Winster Hall was converted into a hydro following the departure of the previous resident, Victorian polymath Llewellyn Jewitt,

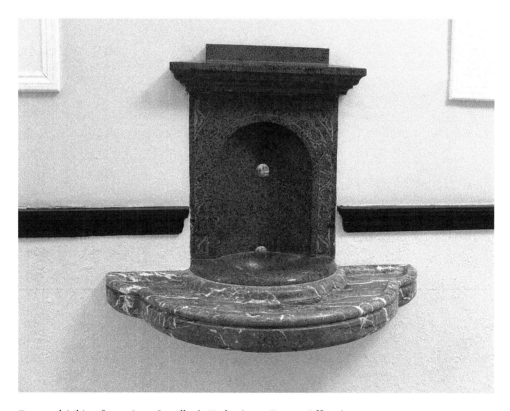

Former drinking fountain at Smedley's Hydro (now County Offices).

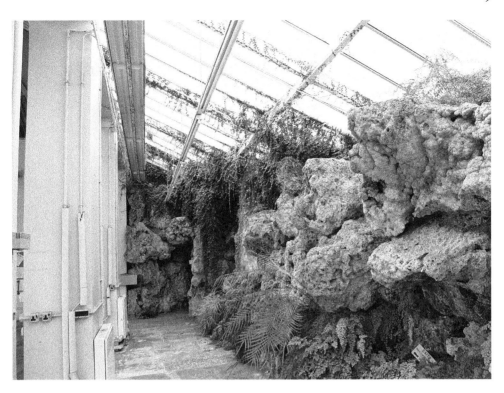

Above, below and overleaf: The tufa grotto in the former Winter Gardens.

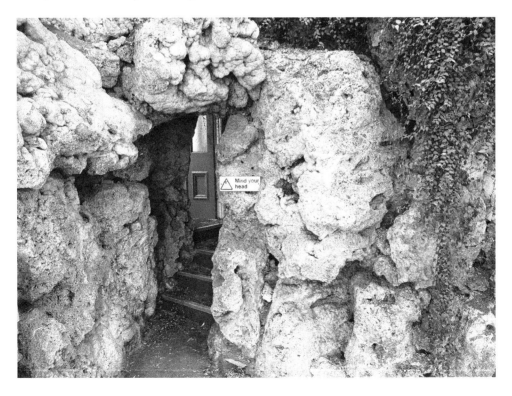

in 1880. The baths were located under the roof in the attic, but the enterprise proved short-lived. This attempt by Winster to reinvent itself as a place of restorative waters is particularly bold given that the village had only possessed its own reliable water supply for less than a decade, at the instigation of the philanthropic Jewitt in 1871. The previous unsatisfactory arrangements for the villagers involved a long walk to a well that, to add insult to injury, was polluted as a consequence of the many lead workings in the area. According to Ebenezer Rhodes, writing in 1822, the villagers had previously been offered by another unnamed local benefactor a choice of gift to the village of either a new church organ or a reliable piped water supply; after much deliberation, the music-loving residents plumped for the organ.

However, before Smedley and company came along, Matlock Bath was the original place to take the waters – hence its aquatic name. Naturally occurring thermal spring waters were discovered in 1696 and the site christened the Old Bath Spring. A bath made of lead and wood was soon established on the site for visitors to bathe in, and Matlock Bath developed as a resort, the original site's facilities later upgraded with the building of the Old Bath Hotel.

Matlock Bath frequently strove to affect a quasi-continental atmosphere, as best exemplified by the reopening of the Royal Hotel (opened in 1878 on the site of the Old Bath Hotel and subsequently to burn down in 1929) in the early twentieth century. It was bought by a London syndicate who undertook an extensive programme of revamping. When relaunched in 1904 as a luxury hotel and hydro, the first manager was a Swiss

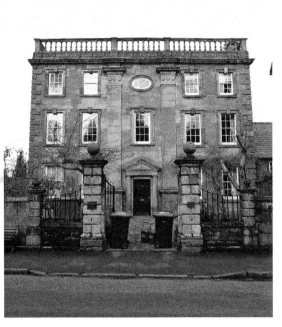

Above left: Winster Hall, home to a short-lived hydro enterprise in the 1880s.

Above right: The remains of a stand tap from Winster's first piped water supply.

gentleman, to be shortly replaced by a German. Guests were entertained by an orchestra from Milan (several Italian musicians were to settle in Matlock Bath and establish families there), warmed by a heating system installed by a Swiss company, ate meals cooked on kitchen equipment supplied by a Paris firm, and walked on carpets that had been imported from Saxony and Brussels.

In 1910, the current Grand Pavilion was constructed on land formerly housing the stables of the Fishpond Inn, to replace a previous older pavilion located on the slopes behind the Royal Hotel. The second pavilion was built under the name of the Kursaal, a German word with the rather specific meaning of a public room for entertainment located at a spa or health resort; Southend, Worthing, the Isle of Man and Harrogate also had their own *kursaals*. With unfortunate timing, within four years of the completion of this new Kursaal Britain found itself at war with the country whose ideals Matlock Bath had been aspiring to, and the name was quietly changed to the less Teutonic-sounding Pavilion. The magnificent 1910 ceramic drinking fountain still exists in the Pump Room, nowadays used for talks by visiting lecturers to the Matlock Bath Heritage Group.

Given that in the twenty-first-century luxury pampering treatments and relaxing breaks at spas have become increasingly popular, it is curious that Matlock and Matlock Bath have so far largely failed to capitalise on their past and reinvent themselves as a

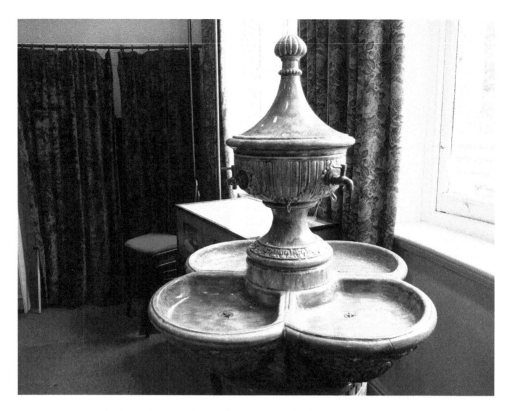

The Pump Room drinking fountain dating from 1910, Matlock Bath Pavilion.

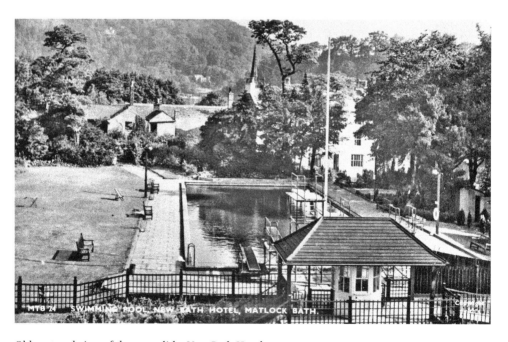

Old postcard view of the 1930s lido, New Bath Hotel.

modern-day spa getaway destination in the way that the Somerset town of Bath has, with its modernised Thermae Bath Spa complex. However, a step in this direction has come from the new owners of Matlock Bath's New Bath Hotel. The hotel closed in 2012, and after lying vacant for a few years was bought by the current owners in 2015, who began a programme of refurbishment. The hotel facilities included both an outdoor lido, opened in 1933, and indoor vaulted plunge pool in the basement – both fed by Matlock Bath's naturally occurring thermal waters. If all goes to plan, both are set to reopen to the public later in 2018.

Matlock Bath's springs were also capitalised on by John and Mary Whittaker, who established a pop bottling factory at Matlock Dale using a naturally occurring mineral spring close to the Heights of Abraham, which was in operation from the 1870s until the 1970s. The family firm produced aerated waters, 'Therlspring' stone ginger beer, and a series of delicious-sounding local alternatives to the output of American conglomerates including lime crush and fizzy grapefruit, all sold under the 'Tordale' trademark. Unfortunately, their 'High Tor' brand of soda water had to be rescinded and renamed when it emerged that an existing Australian brand already had the rights to the name (surely the Matlock Bath-based business in the shadow of the Tor had a greater claim). Kitty Cola and Vimto were bottled at the factory under license, and Guinness and Bass beer brought in barrels to be bottled. The enterprising Bonsall-born Mary Whittaker also owned a show cave, the Long Tor Cavern, which sold fossils, marble and Blue John from its gift shop.

Another of Matlock Bath's watery curiosities were its petrifying wells. In a simpler era before 4D cinema and 4G broadband, people were content to spend their leisure time looking at objects that appeared to have been turned to stone through the gradual

Above and overleaf: Labels of products from Matlock Bath's Whittakers/Tordale pop factory. (Reproduced by kind permission of Peak District Lead Mining Museum)

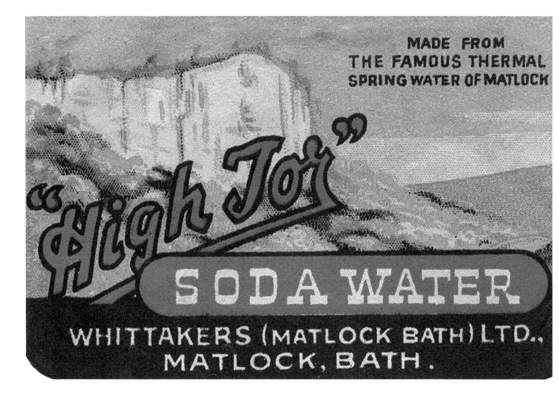

application of water onto them. Such objects in Matlock Bath's case included a human skull, a lioness skull, spinning wheels, a man trap, bird's nests, hats, teapots, teacups, bottles, birdcages, boots, crucifixes and typewriters. A speciality of Joseph Boden's well was the petrifying of deer antlers collected from Chatsworth Park. Richard M. Litchfield on the Old Matlock Pics Facebook group remembered visiting one of the wells as a child in the 1950s and seeing a petrified horse skull smoking a pipe. With characteristic Victorian entrepreneurship, most of these items were available to purchase in addition to being on display.

The only remaining petrifying well is to be found at the Matlock Bath Aquarium, located in the former Fountain Baths swimming pool (now colonised by large fish). In addition to the well and aquarium, the premises also contains an amusement arcade and hologram museum.

Lying in a small gardens next to Twiggs on the road to the area of Matlock that revels in the curious, fairy tale-like name of The Dimple, the Allen Hill Spaw (or Spa) is a chalybeate spring that emanates from the hillside into a little stone wellhouse. The iron content of the Spaw's waters result in a lurid Tango orange-coloured flow that quickly taints the path, fallen leaves and any litter that has been dropped nearby the same hue. An inscription on the well house informs us that the spa was restored in 1824, so its existence in fact predates Matlock's hydrotherapy boom (but not Matlock Bath's). An 1893 guidebook to the area went on a slightly bizarre extended rant about the fact that the Allen Hill Spaw had not been capitalised on, asking, 'where is the Matlock Bridge Pump Room?'

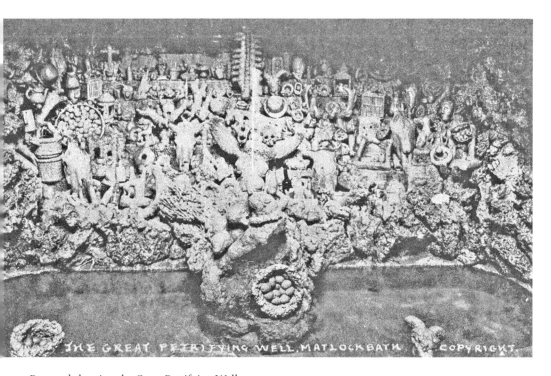

Postcard showing the Great Petrifying Well.

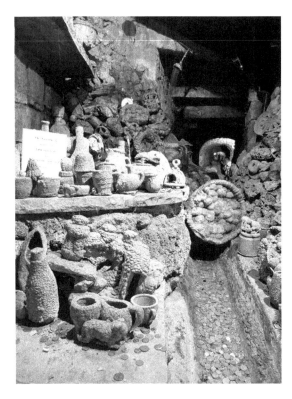

Left: Matlock Bath's last remaining petrifying well, Matlock Bath Aquarium.

Below: An untapped resource: The Allen Hill Spaw.

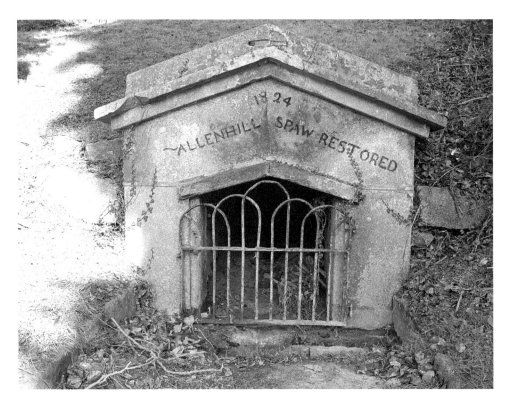

Matlock has a Chalybeate Spa second to none in the country; but although it has been known for some time, no attempt has been made to bring it prominently before the public. In this respect Matlock is as backward as Leamington was a hundred years ago. It is sincerely to be hoped that it will not remain long so, for neglected opportunities have a risk of developing into actual misfortunes. If a commodious PUMP ROOM were erected in the vicinity of the Bridge, and the waters from the Allen Hill Spa conducted there, thousands would be attracted annually to the town by this feature alone ... it is strange that the people of Matlock should neglect their obvious opportunities so far as to wait to have them pointed out.[1]

In another missed opportunity for towns which owe their expansion and development as inland resorts to the qualities of their natural waters, Matlock and Matlock Bath have produced surprisingly few well dressings, the ancient (and tourist-attracting) Derbyshire craft of making designs on a clay-filled board using flower petals and other natural materials, in thanks for the gift of water.

As usual when it comes to watery matters, Matlock Bath was the pioneer. In 1865, the village inaugurated what according to the *Buxton Advertiser*[2] was 'what is henceforth to be the annual custom' of well dressing. The newspaper frothed, 'Perhaps in no other place in the kingdom would the decorator's tastes have better opportunity for display than at Matlock Bath, where the beauties of nature are so abundant, as to lend additional interest to the productions of man'. Special trains were laid on to Matlock Bath from Manchester, Buxton, Sheffield, Birmingham, Leicester, Nottingham and Derby, bringing in huge crowds of daytrippers from the North and Midlands to view the dressings. Dressings continued in Matlock Bath until 1871, with a brief revival in 1914.

Matlock itself was very slow to attempt a well dressing. The first recorded example was in 1978, when the Allen Hill Spaw was dressed at the instigation of local GP and Brownie pack leader Doreen 'Tottie' Holden. The seasoned well dressers of Tissington and Wirksworth offered advice to the Brownies, and Wirksworth County Junior School loaned one of their well dressing frames. 'Lend A Hand' was the theme chosen for the dressing, with the design showing a Brownie helpfully handing a basket to an elderly lady. The *Matlock Mercury* reporting on the event was hopeful that well dressing in Matlock would become an annual event, with more of the town's wells being dressed. Unfortunately, on the Saturday night after the dressing was erected, disaster struck or more precisely, vandals. The Matlock police force were soon at the scene of the crime, reporting that the dressing had been 'clawed'. The town's community rallied round to right the damage, with the Brownies working for six hours and locals and visitors alike lending a hand to scour the area for replacement flowers – a busload of passing Russian tourists somehow even became embroiled in the restoration work (a touching act of unity that appears to have been hitherto overlooked in all existing chronicles of the Cold War). Undeterred, the Brownies produced a few more dressings over the years including a Baden Powell design in 1982 to mark seventy-five years that year of the Scouting movement. In 1984, All Saints' School produced a dressing with

1 Anon (1893), p. 7
2 *Buxton Advertiser*, 20 May 1865, p. 5

a depiction of Queen Victoria designed by a parent, Martin Smith, which was sited in All Saints' Churchyard to commemorate the church's centenary.

The most recent Matlock dressing at the time of writing was a small-scale one produced by All Saints' Church in 2012 as part of their Flower Festival. Hackney, a sprawling hamlet of houses, bungalows, farms and cottages clinging to the hillside between Matlock and Darley Dale, has a number of existing wells dating from the days before piped water supplies, and the villagers began dressing them in 2007, producing some superb designs over the years before the practice lapsed in 2013. Tansley also produced dressings between 2002 and 2011 as part of their village flower festival, and revived the custom in 2017. Riber village made three dressings in 1999, and Starkholmes Guides and St Giles' School also produced dressings for a few years around the turn of the century, decorating an extant well structure close to the village war memorial, the last one to date being made in 2002.

Bonsall began dressing their wells in 1927 when the lapsed village Wakes was revived in the guise of the annual carnival, at the instigation of local primary school headmaster Fred Bunting and the epically named Nehemiah Doxey, proprietor of the village fish and chip shop. In the 1960s the massive societal upheavals of the permissive decade were even reflected in the village well dressings, with some 'controversial' designs including one on an anti-Apartheid theme and one depicting Jesus in modern-day dress attended by a guard in jackboots with sub-machine gun, both of which attracted the attention of national newspapers.

Nowhere in the British Isles is located more than a hundred miles from the coast, but Matlock lies pretty far inland and almost equidistant from the east and west coasts –

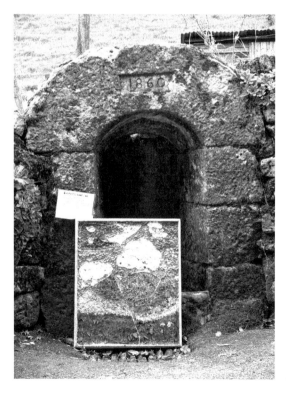

A Bonsall well dressing.

78.87 miles from Skegness Pier and 77.77 from Prestatyn Sands, using Crown Square as a measuring point. We do have the inshore resort of Matlock Bath on our doorstep, however, and until the late twentieth century, another surrogate seaside existed locally in the shape of Flash Dam up on Darley Moor.

The dam is located on land formerly belonging to the Sydnope Hall estate. By the 1920s, water power from it had been utilised to run a power house generating electric lighting and heating for the hall. It was tapped in the 1940s to provide a piped supply to Loscoe Row, a now-demolished terrace of millworker's cottages at Ladygrove.

Many local people have happy memories from their youth of afternoons and evenings spent at the dam during the halcyon hot summers of the 1970s, with children and teenagers making the walk up there unaccompanied from Matlock over Farley. Wild camping and skinny dipping were not uncommon, and speedboats and jet skis were a frequent sight whizzing about on the dam. Even inhabitants of Sheffield, living in the UK's fifth largest city with plenty going off on their own doorsteps, were wont to travel over to Darley to sample the delights of Flash Dam. A member of the online Sheffield Forum remembered trips there in the 1970s as a formative experience, having witnessed his first topless bathers there, concluding 'it was the next best thing to [being] at the seaside for the day'. In winter the frozen dam played host to ice skaters.

While the dam was the scene for many joyful memories, there were also darker episodes. In March 1929, the body of Dr. Marie L'Estrange Orme, a physician at Rockside Hydro and a well-regarded figure in Matlock, was discovered in the waters of Flash Dam. On 22 August 1943, the corpse of a well-dressed, unidentified male aged around forty was discovered floating in the dam by Vincent Elliott of Flash Farm, who had gone up to feed some fowls his father kept in the area. From the condition of the body it was apparent that it had been in the water for some time. Some large stones taken from the bankside were in the man's pockets, and a note was discovered on his person with the enigmatic message, 'The happiest day of my life, August 7th 1943. I hear Darley or Matlock church bells'.

When he found the body, Elliott went to nearby Fir Tree Cottage to fetch Robert Moxon to assist him in retrieving it from the water. This must have stirred some strong emotions in Moxon, for a few years previously in December 1939 he had returned home from work to find a note left by his forty-nine-year-old-wife Alice, who had also committed suicide by drowning herself in the dam. At the inquest it was noted that she had been suffering from ill health following an operation four years previously, and might have believed that she had developed cancer.

The dam still exists in diminished form as an attractive setting for the 'Darwin Lake' holiday village, although some of it was infilled to create this development. In 2006 a family were staying at the complex when Katie and Georgia Turner, then aged eight and five, along with their cousin Martha Bellamy (nine), made an intriguing discovery at the lake: a message from the past inside a bottle. When extracted from the bottle the anonymous note, written on a page of the *Chronicle & Advertiser* (now *The Mansfield Chad*) dated 22 July 1976, read simply, 'Help help help help help', with the instruction on the reverse side, 'Please put this bottle back in the water with the note inside and the cork back on the bottle'.

Above and below: Surrogate seaside: the diminished Flash Dam, Darley Moor.

2. Subterranean Rumblings: The Lead Legacy

Lead mining played a hugely important part in the economy of the Matlock and Matlock Bath area for thousands of years. Roman 'pigs' (ingots) of lead were discovered at Matlock Bank in 1783 (now kept at the British Museum) and a further one on Matlock Moor in 1787, which were stamped with the legend 'Lutudarum'. This is believed to refer to the name of an administrative centre of the lead industry in Roman times, although historians cannot agree on its location – Matlock itself has been offered as a contender, as have the nearby towns and villages of Chesterfield, Crich, Carsington (where the remains of a Roman villa were discovered during a 1979–81 archaeological dig prior to the creation of the reservoir) and Wirksworth. The latter town certainly grew over time to become an important local base for the industry. Records dating from AD 714 show that a coffin made of Wirksworth lead was sent on behalf of Repton Abbey (the then owners of the area's mining rights) for the burial of St Guthlac. Embedded in the south transept wall of the town's St Mary's Church, a carving thought to date to the Anglo-Saxon era, representing a lead miner with a pickaxe and kibble (a lead mining tool), can be found. He is considered to be the oldest image of a miner in the world, and goes by the name of T'Owd Man ('The Old Man' in Derbyshire dialect). He actually originated in the church

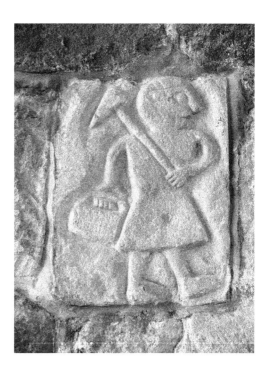

T'Owd Man, Wirksworth Church.

at the neighbouring village of Bonsall. During renovation work there in 1863, the ancient image of the miner was removed along with some other stonework from the church by churchwarden John Broxup Coates, supposedly for safekeeping. Coates took a little too much of a fancy to these artefacts he was meant to be looking after, and they ended up forming a sort of ecclesiastical rockery in his garden at Nether Green House. When this matter came to the attention of Mr Marsh, the High Sheriff of Wirksworth, he liberated T'Owd Man from Coates' garden and took him over to Wirksworth, where he was built into the church wall during St Mary's own renovations in the 1870s. Lamenting their unique lost treasure, Bonsall Parish Council, in 2001, commissioned Wirksworth sculptor Graham Barfield to carve a replica Owd Man for them out of Birchover sandstone, who was installed in Bonsall's bandstand.

Unlike the carving, the definition of what T'Owd Man represented to the past generations of lead miners cannot be set in stone. To them, 'T'Owd Man' could have meant a ghostly spirit of previous mineworkers who still inhabited the mines (to whom placatory offerings were sometimes left for luck); the many past generations of miners who had physically come before; or the lead ore itself – or a combination of all three. A Christmas custom among miners was to leave a candle burning down the mine on a high-quality piece of ore on Christmas Eve 'for the Owd Man'. The tradition is still upheld locally by mining enthusiasts at the Goodluck Mine located on the Via Gellia near Middleton-by-Wirksworth (open to the public on the first Sunday of the month or by prior appointment via their website). David Barrie, secretary of the Goodluck Mine Preservation Club, informed me, 'We still maintain the custom, although in some years the actual day has varied. We try for Christmas Eve, but sometimes it has been done in the few days before. There's about four or five of us that go, and we've also attempted carols. I say attempted, because none of us are great singers...' A candle is also lit for T'Owd Man at Temple Mine in Matlock Bath, owned by the Peak District Mines Historical Society and open to members of the public for tours through the Peak District Lead Mining Museum.

Mining has left its mark physically on the landscape of the surrounding area, with the countryside around Matlock and Matlock Bath scored with odd bumps and ridges on the surface and, more picturesquely, four species of nationally rare 'metallophytes'. These are wild flowers that thrive in the metal-rich conditions of the soil around former mine spoil heaps (where surplus ore was dumped at surface level around the entrance to the mine workings): spring sandwort (locally named 'leadwort'), alpine penny cress, Pyrenean scurvy grass and mountain pansy.

The countryside is also littered with remains of industrial archaeology from mining days. Rusting cranes and machinery remain up on Bonsall Moor, while at Clough Wood at Darley Bridge the churchlike remains of one of the engine houses that used to power one of the huge water pumps at Mill Close Mine can be found. It was reported that when these were operational the water levels in the caverns of Matlock Bath 3 and ½ miles away fluctuated in tandem with the strokes of the pumps! In 1976, members of the North Staffordshire Mining Club discovered a huge engine and pumps in the Wills Founder Shaft at Winster, designed by famous Cornish mining engineer Richard Trevithick, some of which was retrieved and is now in the Peak District Mining Museum.

Rusting remains of lead mining equipment, Bonsall Moor.

The mine workings were not just located out in the countryside, but penetrated right into the urban areas of the district. Knowleston Gardens, a small formal gardens next to Matlock's Hall Leys Park, were created by Chatsworth gardener and Crystal Palace designer Joseph Paxton on the site of former lead mines at the behest of John Knowles, who was also responsible for developing the row of large and elegant villas opposite in the 1850s. Caverns formerly mined for lead in Matlock Bath were reopened as show caves in Victorian times, with guides giving atmospheric tours by candlelight. One incredible legacy of Matlock Bath's mining past is the emergence of the 'Trogs' of the mid-1960s, a band of young and free-spirited people who frequently came to visit Matlock Bath and camped out in the caves (hence their moniker, a shortened form of troglodytes). The national press (and even, somehow, the USA's *Minneapolis Tribune*) picked up on the story, the reporters of Manchester and Fleet Street concocting lurid tales from their office desks far away from Matlock Bath, of all-night orgies, mock marriages, drug taking and Christian Evangelical missions entering the caves in order to save the young people's souls.

Below ground, a network of tunnels, soughs (channels driven to drain water away from the mines, highly impressive and expensive undertakings considering the time in which they were driven, some dating from the seventeenth century) and shafts remain.

These have remained a persistent hazard in the area. I have a distinct memory of doing a project on lead mining at South Darley Primary School (the school was on the doorstep of the former Mill Close Mine, in its heyday the largest lead mine in Europe), and being taken out into the fields of Wensley Dale to study old mine workings where we were sternly informed to stick to the paths to ensure none of us tumbled down a mineshaft.

Knowleston Gardens, built on former lead mines.

Knowleston Gardens with Knowleston Place behind.

We all made it back to school in one piece; others over the years have not been so lucky. The *Derbyshire Courier* of 19 December 1857 reported a tragic story:

Man Killed In A Lead Mine
On Friday last, a poor man, named Thomas Thorpe, went from his cottage at Bonsall to Mr. Greaves', Cliff House, Matlock, to beg a handful of mint, and not returning on that night or the next, his wife and family became seriously alarmed for his safety. On Sunday morning some neighbours went in search, and ascertained that Thorpe had left Cliff-house with a quantity of mint, about six in the evening of Friday. They then tracked his course homewards, by leaves and sprigs of mint, to a mineshaft on Masson, then recently run in, but there the traces of the mint ceased. On removing the rubbish in the hole the poor fellow was discovered about six feet from the surface, of course quite dead, and the body was removed to a farmhouse near to await a coroner's inquest.

Mineshaft mishaps continued until well into the twentieth century. In 1974, twelve-year-old Andre Peat of Nottingham fell 80 feet down a disused mineshaft on Masson hillside, although unlike Thomas Thorpe was thankfully retrieved alive. In the same year a woman (also from Nottingham) who was collecting moss to make a wreath fell down an overgrown mineshaft on Middleton Moor. She had become separated from her husband, who was also out moss-gathering and only realised what had happened when he spotted his wife's scarf entangled in a shrub above the shaft.

For the sake of people's safety – and the town's tourism industry before people from Nottingham began to boycott visiting Matlock – the Peak District Mines Historical Society (a hardy bunch of enthusiasts whose members combine a love for mining history with a penchant for squeezing themselves into cold, dark, narrow spaces) and Derbyshire County Council embarked on a programme of capping off the shafts.

In spite of this, to this day they remain a hazard for local populations of sheep and cattle, who still somehow manage to tumble into them. A cow had to be rescued from the Beans and Bacon Mine workings on Bonsall Moor in 2014 – a team from Derbyshire Caves Rescue Organisation freed the hapless bovine who was stuck 4 metres underground by enlarging the passage and coaxing the animal out from an alternative entrance to the mine, where it emerged and began to eat grass apparently unconcerned by its subterranean adventure.

The fact that this is an age-old occurrence (no doubt to the annoyance of generations of local farmers) is highlighted by the lyrics of a poem composed by the improbably named seventeenth century Barmaster Edward Manlove, which encompasses the many quirks of the lead mining laws, as a handy *aide-mémoire* to the miners in an era before mass literacy. It contains the lines:

the Court may fine
For their contempts (by custom of the mine);
And likewise such as dispossessed be,
And yet set Stows against authority;
Or open leave shafts, or groves, or holes,
By which men lose their cattel, sheep or foles

Capped-off lead mine shaft on Bonsall Moor.

More dramatically, in 1992 a large portion of a Starkholmes garden vanished into a huge crater in the ground owing to an unfortunate sequence of events. The seed for catastrophe was sown a few years previously when the homeowner dumped some heavy quarry waste on their land when landscaping the garden. Unbeknown to them, this crushed a clay culvert underneath the ground, which was laid as part of mining explorations at the Riber Mine on nearby Riber Hill in the early 1950s.

A three-month spate of heavy rainfall a couple of years later led to the emergence of an ever-widening hole in the garden. The Big Hole of Starkholmes, as it came to be known, gradually filled with water as a consequence of the ongoing incessant rainfall. This standing water quickly vanished one evening and immediately afterwards all the lights in Starkholmes and Matlock Bath in the valley below went off; the water had quickly forced its way underground, severing an electricity cable.

The Bradley family were on the cusp of buying a newly built house at Starkholmes at the time of the Big Hole's appearance, but my parents swiftly decided to pull out of the sale (although the house in question, along with the rest of Starkholmes village, is still standing a quarter of a century later, and has at the time of writing recently come on the market again).

Interviewed in 2007, Harry Higton of Wirksworth, one of the miners who worked the Riber Mine in the '50s, remembered the origins of the enterprise. Higton responded to an

advert in the *Matlock Mercury* stating 'Driller Wanted', and went with his friend to meet a representative from Johannesburg Consolidated at Matlock Bath station. They were duly hired, performing prospective drilling at first in the Matlock Bath area, and subsequently up into Starkholmes and Riber. While some ore was found, the mine was not a huge success, as T'Owd Man had got at most of the lead already. While working underground Higton discovered a sixteenth-century wooden pump used to unwater the mine workings, as he explained: 'All it was, like a big tube, about 8 foot high, it had got a hole at the bottom with a piece of leather on which was like a clack valve, and then a feller'd stand, pull the rod up and down like that, and the clack valve'd open and shut as it went into this motion. Then it lifted the water about 8 foot up you see, which allowed 'em to go a little bit deeper.'[3]

The discovery was of sufficient historical value that it was swiftly whisked off to the Science Museum in London[4]. Higton remembered: 'I wasn't on the surface when they fetched it, but one of the lads said they wrapped it up all in polythene, squirted all preserve on it you know, to preserve it. Very interesting, that.'[5]

In the same interview Higton reminisced about finding miner's pipes (some of which were made of a hollowed-out bone that were stuffed with tobacco) and old shoes down the mineshaft, which – unlike the pump – were not recognised of being of value and were simply thrown away, something that he regretted looking back from the vantage point of 2007. Old wooden wheelbarrows and shovels were also found, which disintegrated as soon as they were touched.

Once a vein of ore had been discovered, the prospecting miners gave it a name to mark it out as their own, in much the same way that an inventor patents a product. Many of these colourful mine names have a strange poetry of their own: Ringing Rake, Moletrap Rake, Newthole Vein, Gentlewoman's Pipe, Old Eye, Cod Beat, Fiery Dragon, Burning Drake, Yule Cheese Level, Tear Breeches Mine, Placket Mine, Bear Pit, Godbehere Vein, Lords and Ladies Mine, Hang-worm Mine, Owlet Hole, Jackdaw Vein, Horsebuttocks Mine and the aforementioned Beans and Bacon Mine all being examples in the Matlock and Matlock Bath district. Mining tunnels underneath Wensley village bear the names Gnasher Crawl and Thrutcher's Paradise – both of which would also make excellent names for 1970s prog rock bands.

3 Derbyshire Record Office FILE 920 HIG – Higton, Harry – Transcript of oral history interview, 2007
4 Science Museum permanent collection object number 1956-275
5 DRO Higton, 2007.

3. Secret Messages Hidden in Buildings

The most conspicuous crown in Matlock town centre is the metal sculpture in the middle of Crown Square roundabout. However, another subtler one exists nearby, carved in stone on the building on the corner of Bank Road. When first built this was the Crown Hotel. M. J. Arkle, a teacher at Matlock's All Saints' Primary School, recorded a nice story regarding this crown in his 1983 local history book *Tuppence Up, Penny Down* (the title refers to the fare system on Matlock's short-lived cable tramway system, which between 1893 and 1927 ascended the incredibly steep Bank Road – hence double the price for going uphill). Arkle spoke to a Mr W. R. Bradbury, ninety years old at his time of writing, who was the son of a master stonemason based in the railway station yard. This carved crown on the corner was Bradbury's father's handiwork, and as he died prematurely in 1904 its presence in the town provided a tangible reminder of him for Mr Bradbury Jr throughout his long life. The Crown building that features the carved crown is actually the second of three establishments bearing that name in Matlock. The first Crown, located in the vicinity of the older of the town's two bus stations, was a common lodging house of low repute frequented by itinerant labourers, wanderers and travelling performers, who brought bears along with them to perform at the town's Wakes Week held in the same area (the bears were put up in the Crown's cellars!). The building was demolished in 1906, by which time the second Crown was

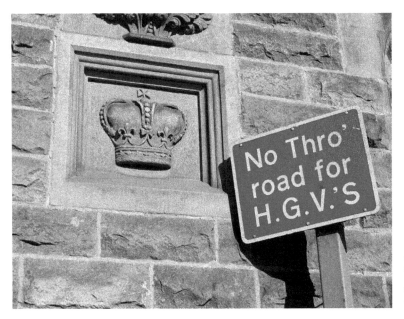

Crown carved by Mr Bradbury on the former Crown Hotel.

The Square, Matlock Bridge Valentine's Series

Old postcard of Crown Square showing the Crown Hotel.

open, a far more respectable establishment. Matlock's third and final (to date) Crown is the current Wetherspoons pub further down Crown Square.

Crossing over Crown Square and into Hall Leys Park, round the back of the Nationwide Building Society on the mock-Tudor gable end is an elephant, an unexpectedly exotic presence in a Derbyshire market town. This is a reminder of the building's former use as Burgon's grocery stores, and was the chain's trademark. Originally the elephant appeared in the form of a wooden relief carving, adorned with Burgon's brand name 'Namunah'. Unfortunately, during renovations to the building in the early twenty-first century, when Namunah, by now nearly a hundred years old, was removed from the wall for temporary safekeeping he disintegrated. Now only his painted shadow remains, but at least the owners have maintained the link with the building's past. A fellow surviving Namunah elephant – a cousin of the Matlock one, if you like – can be found in the form of a mosaic tiled floor at the entrance to a chemist's shop on Melbourne Street, Stalybridge, Greater Manchester (another former grocer's shop).

DID YOU KNOW?

The builders who were digging the foundations of Burgon's grocers made the grisly discovery of a human skeleton. An inquiry speculated that it could have belonged to a criminal buried at the nearby crossroads.

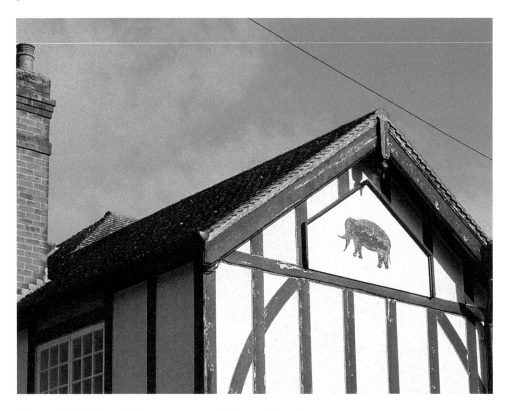

Namunah's shadow: elephant on the rear of former Burgon's grocers stores.

Leaving the park and crossing over Matlock's ancient thirteenth-century bridge, turning left we enter Dale Road. On the right-hand side of the street (facing Matlock Bath), the shops which at the time of writing are Fat Boys and Kick Off are housed in the premises of Matlock's first town hall and assembly rooms, opened in 1868, which also contained a downstairs market hall. A series of stone carved shields with curious (and unidentified) insignia can be seen on the frontage.

A little further along on this side of Dale Road, on the building that currently houses Quirky Antiques, is a 'ghost sign'. These curiously poignant reminders of the transience of life recall a slower-paced world where advertising signs were carefully painted by human hand. The paint remains, faded over time, inviting us to buy products that are no longer produced and patronise establishments that have long since gone bust. This one promotes Frisby's shoe store, promising stock at London store prices. Another Matlock example can be found on the former Rock Cafe Tea Rooms near the former Rockside Hydro. The premises have since been turned into a house – happily the occupants have kept the portion of the wall bearing the sign unpainted as a piece of Matlock history.

While the former Smedley's Hydro has had a subsequent life as County Offices, a reminder of its original incarnation can be seen in the winter months when the climbing plants die back, revealing the ghostly imprint of the 'SMEDLEY'S' lettering, once highly visible from the town down below. On Chesterfield Road, the former hydro, which was known as Jeff's Poplar

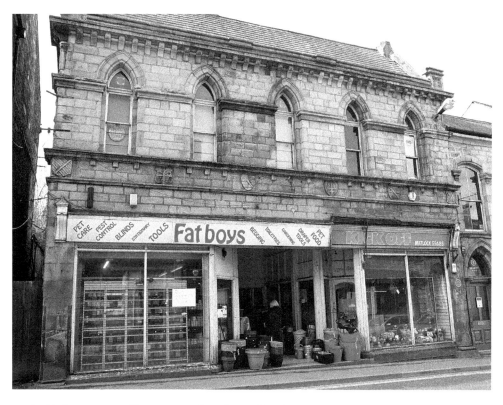

Matlock's former Assembly Rooms and Market Hall, Dale Road.

Detail of one of the shields on former Assembly Rooms.

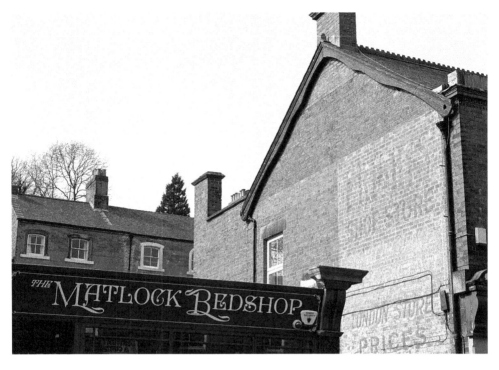

Ghost sign for Frisby's Shoes, Dale Road.

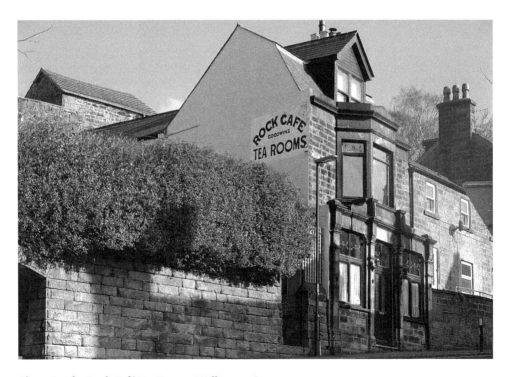

Ghost sign for Rock Café Tea Rooms, Wellington Street.

Faded 'SMEDLEY'S' lettering on County Offices.

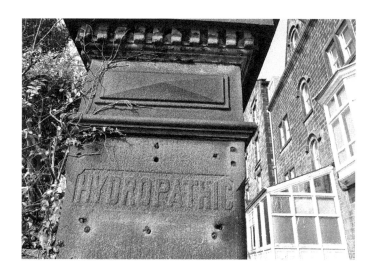

Chatsworth Hall, former 'Hydropathic Establishment', now offices.

Hydro and Chatsworth Hydro (now used as overspill offices by the County Council), still has the words 'HYDROPATHIC ESTABLISHMENT' carved into its stone gateposts.

The area leading from Matlock Green up to St Giles' goes by the name of 'Old Matlock', and unsurprisingly contains some fine old properties. In the front wall of a cottage opposite the church lychgate is a stone with a curious eroded message, which appears to read 'Here Lyeth the Body of a Witch' (take care if you are going to investigate for yourself as there is no pavement). According to members of the Old Matlock Pics Facebook group the lettering has become less readable over the course of the last few decades, but it remains an intriguing object for speculation: was the alleged witch deliberately buried here, pointedly *just* outside of the churchyard, or was a redundant broken gravestone recycled in the building of the cottage wall? Do estate agents highlight the presence of a buried witch when the house comes on the market? The house next door was formerly

The King's Head (drinkers of Old Matlock were formerly well-catered for; in addition to the King's Head and the extant Duke William next door, the grand and obviously old residence opposite, Wheatsheaf House, was also at one stage an inn). Now converted into a house, the former King's Head retains the old mounting block outside to aid customers in getting back on their horses when leaving the premises.

Further up the road at Starkholmes village, a house on Starkholmes Road has reclaimed a peeling sign advertising entrance to the nearby High Tor Pleasure Grounds (admission 6p each – children half-price).

Folk art or art brut are terms employed to describe naïf forms of art practiced by people who feel impelled to create, but have received no formal fine art training. Out in the provinces around Matlock examples could once be found of people who had used their self-taught artistic skills to adorn their homes, elevating them into something more transcendental than a mere dwelling house in the process.

A former house at Tansley in a row of cottages was known as 'Proverb Cottage'. It contained numerous carvings of sayings and proverbs set into the walls, the work of a local schoolmaster called W. E. Cooke and dating to around 1775. In the 1930s the row of cottages was condemned by the district health officer and slated for demolition. By the 1950s this had still not happened, presumably owing to the intervention of the Second World War. When the property was condemned in 1936 Councillor F. W. Beddington made a plea for the retention of the stones, which was honoured, although those that were preserved have been scattered around Tansley – some are built into the walls of Jackhill Farm and other properties in the village. The two fragments illustrated on page 36 are kept at the village church.

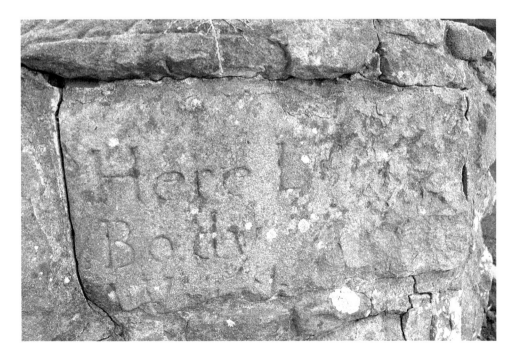

'Here Lyeth the Body of a Witch'.

Cottage with burial stone (left), and former King's Head Inn (right).

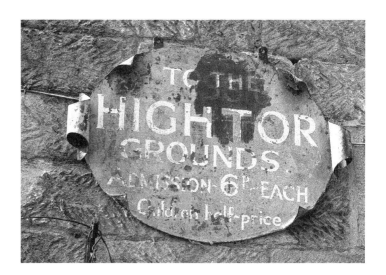

Sign for High Tor Pleasure Grounds, Starkholmes.

On Wheatley Road in Two Dales is a house formerly known as 'Thimble Hall' and also several different names according to the whims of the owners, who painted various scenes onto the whitewashed exterior walls. In a 1900 feature called 'Odd Things From Everywhere'[6], *The King* newspaper's astoundingly condescending reporter ran a short feature on the house, at that point in time going by the name of the 'Klondyke Hotel': 'This remarkable building is called "Klondyke Hotel," but it is neither situated in the golden

6 *The King*, March 3rd 1900, p276. In case you were wondering, the other oddities featured were some iron
 rings and staples found embedded inside a tree when it was cut down; a tree in the graveyard of Lyston
 Church, Suffolk, with a growth resembling an owl's face; a parsnip that had grown through the neck of a
 bottle; house decorations made out of seashells by natives of the West Indies; and damage done to a house
 by lightning strike in Hessle, Yorkshire.

Fragments of
stones rescued from
Proverb Cottage
kept in Tansley
Church.

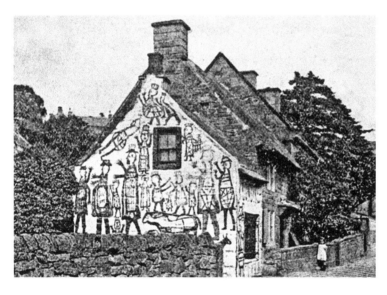

The 'Klondyke
Hotel', Two Dales.

region from which it takes its name nor is it a hotel. It is simply a two-roomed cottage which
stands on the high road in an obscure Derbyshire hamlet called Two-Dales.'

Having been disparaging about the locality, *The King* then really went for the jugular
with regards to the owner of the house:

It is tenanted by a half-witted old man who endeavours to attract attention and coppers
from the casual passer-by in this strange manner. Five or six years ago the eccentric
tenant designated his cottage "The House of Lords," later on it was re-christened "The
Belfast Castle." During the Klondyke rush, the cottage having been re-whitewashed, the

old man thought it was a good opportunity for a fresh display of his talent in the art of house decoration, so he set to work with a little black paint, and gave his dwelling place an up-to-date name with the result shown in our photograph.

George Walters (a native of Two Dales who grew up on Sydnope Hill), when interviewed at the age of eighty-five by folklore collector Dave Bathe in 1984, could remember the existence of Thimble Hall from his younger days, fleshing out the story by giving a surname to the inhabitants and revealing the customisation of their house was the work of a pair: 'this Thimble Hall was an old house, and there was two men named Travis lived there during the Boer War, and they whitewashed the gable end of the house, and they drew effigies of Cronje and Kruger and Boer officers, you know, on this wall ... [the house] was only one up and one down.'[7]

Photos kept at the Derbyshire Record Office taken by the Matlock Bridge photographer W. N. Statham depict the cottage in its Boer War phase. The whitewashed, thatched cottage with wooden shuttered windows is seen covered in the legends, 'Please Leave A Copper', 'Boer', 'Oom Paul', 'Will Want Ogdens Guinea Gold Cigarette', 'Bobs Pretoria', and the caricatures of Cronje and Kruger.

Who were these two Travis men, and what was their relationship? Father and son? Or – I sensed more likely – brothers? The final piece of the jigsaw arrived unexpectedly in the reading room of the Derbyshire Record Office one afternoon in March 2018. I had earlier consulted the photographs on a visit to the Record Office about a year previously. There was no real reason at all to see them again, but as I had been writing up this part of the manuscript a couple of evenings before, I decided to give them another look. Included in the bundle with the two professional Statham photographs was a much smaller, fuzzier amateur snap of the decorated cottage, with the caption 'Thimble Hall' written in biro. As I idly turned the photo over in my hand before wrapping it back up with the others and moving on to my next bundle of documents I had requested from the strong room, I noticed there was some more writing on the back of the print. Written in tiny, hard-to-decipher spidery handwriting by an unknown hand was squeezed nine verses of a poem entitled, 'Harry & Joe – A Simple Tale of Darley Dale'[8]. The verses confirmed my suspicions that the Travises – Harry and Joe – were indeed two brothers 'whose hearts beat as one', and gave more biographical detail about them. The poem tells us that Harry suffered with some sort of pain, however, 'Of stories he had stock galore/His tap room cronies to regale'; the writer speculates that if he had been educated he might have become a successful author. Joe 'gave his life/To help his suffering brother/With the devotion of a wife'. According to the poem Joe was the self-taught artist who decorated Thimble Hall; again, the poet suggests that had he received formal training in art, 'He might have sketched great ladies'. In an era before rolling twenty-four-hour television news coverage and the internet, the changing paintings on the cottage provided a link to

7 University of Sheffield, Dave Bathe Collection, ACT/97-003/A0193, George Walters interview (cassette tape), 21/1/1984

8 Derbyshire Record Office D310/3: photograph of Thimble Hall Cottage at Two Dales, with end section of building painted with Boer War characters

events in the outside world for the people of Two Dales: 'And thus the village late/In news, soon got to know what's what'. The poem concludes poignantly with the death of Harry, and within a fortnight of his passing his brother Joe also dies.

The brothers were sufficiently well known in the district that the news of their deaths made the 'Gleanings in the Peak' column of the *Derbyshire Times*, confirming the story in the poem, although slightly contradicting it, the paper has Harry, and not Joe, as the artist brother. The 12 April 1900 edition reported,

> Visitors to Darley Dale will regret to hear of the death of a well-known character in the place this week, in the person of Harry Travis. Travis who was about 70 years of age gained notoriety in the district by the remarkable mural paintings and hieroglyphics with which he adorned the wall of his house at Two Dales, to the amusement of visitors to the locality.

The edition for 29 April records that Joe has also died, his death 'in a measure attributable to grief'.

The house nowadays, extended and modernised (the gable end that was formerly painted by Joe or Harry appears to have been demolished at some point and a recent extension built in its place), goes by the name of Yew Tree Cottage. Are the current occupants aware of its past as a frequently changing canvas for the imaginations of the previous occupants? It is also interesting to speculate which modern-day topical events might have attracted the attention of the Travises were they still around (Brexit Cottage? Trump Towers?).

The 'Klondyke Hotel'/'Thimble Hall' today.

4. Local Customs, Folklore, Legends and Recipes

In common with most societies worldwide, the people of Matlock and surrounding district adhere to a series of complex rituals or 'calendar customs' that occur at certain points of the year to mark and ensure the smooth turning of the seasons.

The mills located along the banks of the River Derwent between Matlock Bath and Derby (via Cromford and Belper) played a hugely significant part in the Industrial Revolution of the nineteenth century, and are hence now recognised by UNESCO as a World Heritage Site. Before these mass-producing mills changed the pace of life in the western world forever, human existence was dominated to a much greater extent by the rhythms of the agricultural year. After a Christmas break for rest and feasting, the farming year began again on Plough Monday, which fell on the Monday after Epiphany (6 January). This was marked in boisterous fashion by teams of Plough Bullocks, farm labourers who toured the local district dressed in fantastic costume, towing a human-drawn plough behind them and performing rough music and guising plays, with the aim of exhorting collection money out of householders and spectators. This extract from the *Derbyshire Courier* of 13 January 1849 gives us some idea of the flavour of proceedings:

> PLOUGH MONDAY – About 50 plough bullock, followed by an excellent plough, and preceded by the Matlock brass band, started from the Horse & Jockey, Matlock Bank, to Matlock Bath, Cromford, and Starkholmes, and returned to the Bank, where a good supper awaited them, provided by the worthy hostess, Mrs Wall. After supper dancing commenced, and was kept up til early in the morning, concluding with the cushion dance. There has not been so many bullocks to so few ploughs witnessed in that locality for the last 20 years. Four harlequins, who formed part of the cavalcade, astonished both the bullocks and the bystanders. The subscriptions amounted to £4 10s.

On Shrove Tuesday at 2 p.m. the annual Winster Pancake Races are run down the village Main Street from Winster Hall to the Market House. They are competed over several classes, from pre-schoolers to pensioners.

On the third Wednesday in April at noon, the Wirksworth Great Barmote Court for the Low Peak sits at the Moot Hall. Now largely a ceremonial occasion, in lead mining's heyday the court would regulate matters relating to the industry.

On Good Friday at Cowley Knoll in Stanton-in-the-Peak, an annual squirrel hunt was formerly held, with the men and boys from surrounding villages forming a baying mob to take part.

May Day was formerly widely celebrated as marking the joyous return of summer following the long, dark and barren period of winter. While we may imagine Derbyshire farmers to be a taciturn and practical breed, in former days a charming custom was

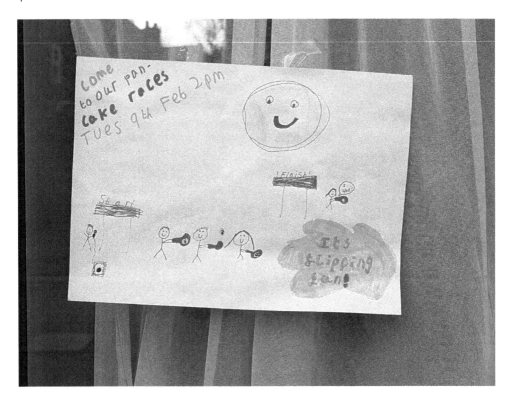

Above: Flipping fun: Winster Pancake Races.

Left: Winster Pancake Races in action.

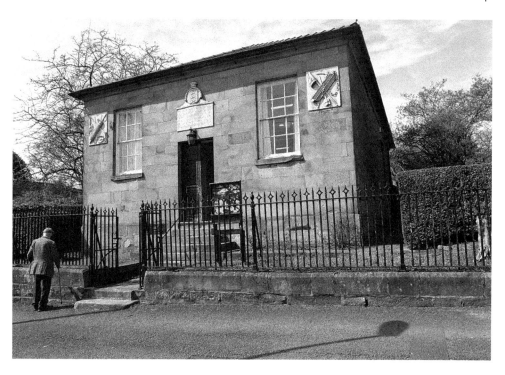

The Moot Hall, Wirksworth.

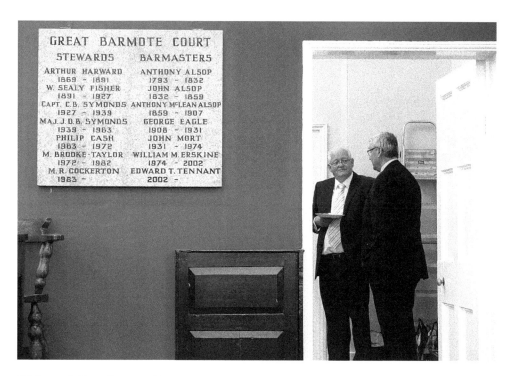

Wirksworth Great Barmote Court.

upheld by the farmers of Winster and Elton to mark May Day when they decorated their horses and carts laden with milk churns with greenery for the journey down to Darley Dale railway station to meet the milk train.

Another much-anticipated respite from the daily grind was the annual Wakes Week, where a travelling fair with stalls and rides would roll into town and set up on a local showground. In *The Country Child*, a work of fiction that draws heavily from her own childhood at Castle Top Farm, Alison Uttley paints a vivid picture of the annual Wakes, which Susan and Becky visit in chapter eight, based on those held annually at Cromford. The girls experience the excitements of rides including dobby horses, Aunt Sally's, swing boats and a merry-go-round; sideshows and stalls including a 'fat woman' with a head like 'a great pudding', a calf with two heads, chicken with four legs, a Pepper's Ghost illusion, rifle shooting booths, and a coconut shy; and stands selling brandy snap, peppermint rock, striped sugar sticks, gingerbread men and Wakes Cakes spiced with caraway seeds.

In less enlightened times, dancing bears, cockfighting and bull baiting were 'attractions' at the Wakes. Snitterton still retains its old bullring set into the ground.

Snitterton Bullring.

Over time, the annual Wakes Week evolved into Matlock Carnival. A speciality of these celebrations were 'Sprogs' (not to be confused with Trogs – *see* 'Subterranean Rumblings: The Lead Legacy'), large papier-mâché creations built over pram wheels and piloted by teams of several men inside them.

DID YOU KNOW?

The stone tablet on the wall of the Moot Hall records Bakewell solicitor Michael Brooke-Taylor's tenure as steward of the court from 1972–82. The Brooke-Taylors are a Derbyshire dynasty of solicitors, formerly having offices in Matlock, Bakewell and Buxton. Michael's Buxton-born cousin Tim dutifully went down to Cambridge to study law, but having joined the Footlights there ended up entering the world of showbiz instead, joining fellow Cambridge alumni Graeme Garden and Bill Oddie to found an agency that did 'Anything, Anywhere, Anytime' in psychedelic 1970s comedy series *The Goodies*.

Winster still holds its Wakes Week in late June/early July, scene of much feasting, merriment and an appearance from the Winster Morris Dancers. The *Derbyshire Times* of 1 July 1899 reporting on that year's Wakes recorded a dramatic interjection from the modern world into the proceedings:

This year the arrival of a motor car caused a sensation, as it was the first time a horseless carriage had been seen in the town. The occupants made their entry in very undignified fashion. Not being acquainted with the road, they came down the steep declivity known as Winster Bank [*sic*] at a furious rate. The gentleman in charge lost control of the car, which ran into a trough at the reservoir. In jumping from the carriage, both the lady and gentleman were shaken. The car was left for alterations and repairs with the local blacksmith.

Matlock's St Giles' Church stages an unusual ceremony on the first Sunday in July. The annual Blessing of Transport is timed to coincide with the monthly Family Eucharist and is held in July to mark Saint Christopher's Day later in the month on the 25th. He is the patron saint of travellers (hence the superstition, not confined to those of a religious nature, of carrying a medal bearing his image as a talisman for safe journeys). 'It is not that we believe that there is anything magical happening when we bless our bikes and cars', explains the church's website, 'It is simply a way of asking God to help us as we travel, to protect us from danger, and to guide us to be good and courteous travellers, using the roads and public transport in a considerate and careful way.' The ceremony was introduced to the church by the current vicar, Father Mark Crowther-Alwyn, who explained to me, 'I remember a similar blessing when I was a child at the church

 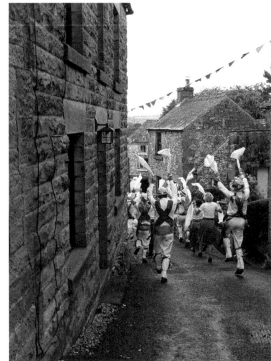

Above left and right: Winster Morris Dancers at Winster Wakes.

I attended in Ipswich and that is where I got the idea from. Since then, I have heard that it is common practice in Roman Catholic countries.'

I attended the blessing ceremony in 2016. The opening hymn is the aptly chosen 'One More Step Along The World I Go', with its refrain of 'Keep me travelling along with you'. Emily Brailsford, who was in my form at secondary school up the road and is a member of St Giles' congregation, gives a reading during the service explaining that as well as St Christopher's well-known role as the patron saint of travellers, he is also the patron saint of epilepsy, gardeners, storms and toothache (I look him up afterwards and in addition he is the patron saint of bookbinders, fruit dealers, archers, bachelors and surfers. Whoever said men can't multitask?). At the end of the service prayers are said for safe travel and for those whose work involves regular travel. As the church organ plays rousing chords, Father Mark makes his way to the back of the church where a collection of bikes, children's scooters and wheelchairs are parked up, and sprinkles them liberally with holy water before making his way outside. Here various churchgoers' cars are doused with holy water – including a beautiful hand-cranked vintage motor and a motorbike. 'Can you give it a wax and polish as well?' requests one waggish member of the congregation.

Wirksworth's Wakes Week has given way to the Wirksworth Festival staged in mid-September (the same time their Wakes were held). This is a major and impressive arts event for a small town, which, formerly dominated by the tough industries of quarrying and lead mining, nowadays revels in the patchouli-scented whiff of mild bohemianism.

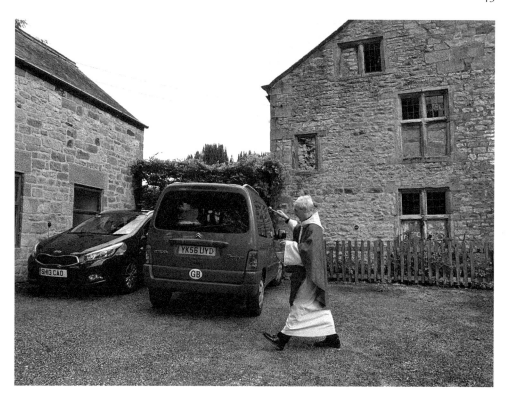

Above and right: Blessing of Transport
ceremony, St Giles' Church.

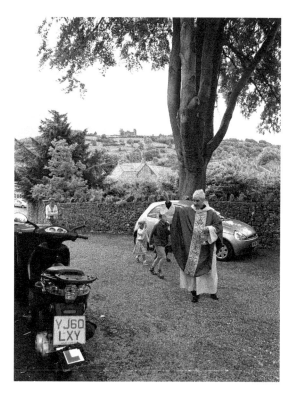

Culture-crawlers and Radio 4 listeners descend on the Derbyshire Dales en masse, and there is so much going off across Wirksworth over the fortnight, it is easy to miss a curious ceremony that takes place at the ancient Church of St Mary. This is the Wirksworth Church Clypping, held on the Sunday nearest to the 8 September and revived in 1921 at the instigation of the oddly named Provost Ham. A church service begins at 3 p.m. in normal fashion, but then halfway through, the congregation files out of the building singing a hymn, led by a church official brandishing a large crucifix on a pole. The idea is to figuratively 'embrace' the church by holding hands and forming a circle that goes the whole of the way around the building. Folklorists speculate that the ceremony – one of a handful of similar ones that take place around the country including at Painswick in Gloucestershire and Tankersley near Barnsley – is a hangover from pre-Christian pagan rituals, although Wirksworth Team Ministry's Canon Martin Hulbert was unconvinced when presented with this theory: 'Not impressed by the claim of a pagan origin. Might be true, but a big gap up to 1921'.

On my 2015 visit, a gung-ho vicar was marshalling bewildered art lovers who happened to be in the vicinity of the church at the time into participating: 'Ring the church! Face the town – your town!' There's a very British sense of awkwardness to the proceedings: lots of shuffling round into place and a fair few people not really knowing what it is they are meant to be doing and why they are being coerced into holding hands with strangers, but in the end the large church is successfully ringed.

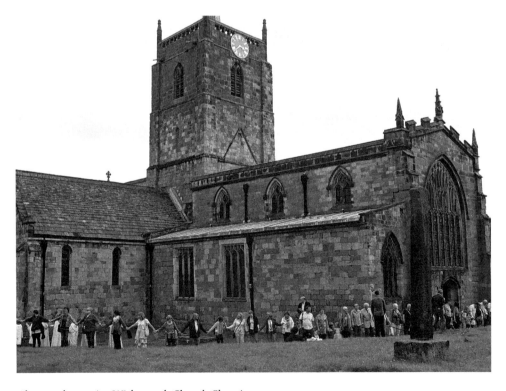

Above and opposite: Wirksworth Church Clypping ceremony.

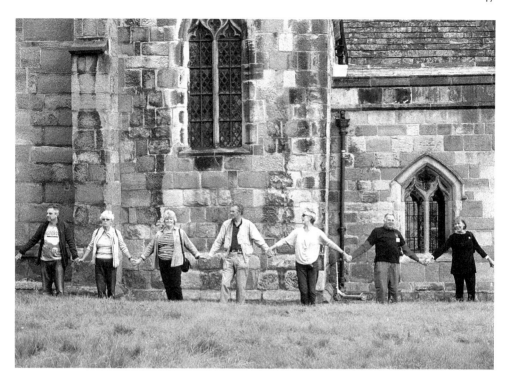

The coming of Autumn and the drawing in of the evenings mean that it is time for the Matlock Bath Illuminations, or 'Venetian Nights', to begin. These run on Saturday and Sunday nights throughout the majority of September and October, and have a long pedigree, being staged since 1897 when they were first held to mark the visit to the resort of Queen Victoria. In a charming link with the event's Victorian origins, the first boat that takes to the River Derwent is illuminated entirely by candlelight, as the boats that Victoria would have seen were – some of the original Victorian candle-glasses are still in use over 100 years later. A series of elaborately decorated electrically illuminated boats follow. Weekly themed children's fancy dress competitions and firework displays complement the entertainment. In an era where it is common for local councils across the country to have outsourced essential services (with mixed levels of success), admirably, the Illuminations are still organised in-house by Derbyshire Dales District Council, and attract large crowds to Matlock Bath after the end of the summer season – a big boon to local traders.

In common with the rest of the country, the Matlock area celebrates Bonfire Night on the 5 November. Bryan (1903) records that a large communal bonfire was held at Matlock Bath until the mid-nineteenth century, and in the weeks leading up to it the young men of the village collected fallen branches from the local woods to contribute towards its construction. One particular year the end result was of such gigantic proportions that it didn't stop burning for a week. In addition to the usual accompanying fireworks, miniature cannons and iron pistols were also fired. Bryan ascribes the demise of this great bonfire to the establishment of a local police force!

Barbara Haywood, a resident of nearby Middleton-by-Wirksworth, which is famed for the quality of its stone from the Hopton Wood Quarry, recalled in her memoirs that in the early years of the twentieth century (an era when health and safety measures were somewhat more lax than today) the village Bonfire Night celebrations were spiced up a little. The quarrymen used gunpowder during shot firing, and when the 5 November rolled around they used to 'liberate' quantities to give to the village lads. The boys would lay a trail of powder down the main street and set it alight, resulting in a series of miniature explosions running from one end to the other.

Readers of a similar vintage to the author will no doubt recall the large bonfires held in Matlock's Cawdor Quarry in the 1980s and 1990s, before the site was developed for a supermarket. Most of Matlock and the surrounding villages seemed to be in attendance.

Another local peculiarity around Bonfire Night was the making and eating of Thor, or Tharf Cake, made with oatmeal, treacle and ginger and taking either the form of a parkin-like cake or biscuit, depending on which recipe is followed. Crichton Porteous, writing about the baking of Bonfire Night Thor Cake in 1960, noted that 'A few old people in Matlock and around still keep this up.' I wrote to the *Matlock Mercury* just after Bonfire Night 2015 and the *Derbyshire Times* in early 2016 to see if anyone in the Matlock area still went to the effort of baking them at home as part of the celebrations, but failed to draw any response from the townsfolk. It is still possible to sample this traditional seasonal dish should you so desire, however – and all year round, too – if you pay a visit to Wirksworth. Here at May's Tearooms on Coldwell Street, Thor Cakes can be purchased along with a wide variety of other sweet treats. I was informed that May Greatorex, the octogenarian proprietress, found the recipe she uses in an old magazine cutting.

If you feel the urge to revive this old Matlock tradition and bake up a batch of Thor Cakes yourself for Bonfire Night, then Alison Uttley supplies two different recipes, one

Bonfire Night Thor Cake, May's Tearooms, Wirksworth.

of which was collected from a Carsington farm kitchen, in her 1966 book *Recipes From an Old Farmhouse* (reprinted in a posthumous updated edition in 2010 as *Old Farmhouse Recipes*, with editorial advice to omit laudanum and saltpetre from the recipes!). Uttley notes that Thor Cakes were consumed during the Wakes as well as in November, when they were eaten outside with mugs of warm milk or spiced elderberry wine.

I came across reference to an obscure annual midwinter custom in the archives of folklorist Dave Bathe (more of whom shortly). Despite subsequently poring over many books on local folklore and history, I have never seen it mentioned in print elsewhere. The event was called Wirksworth Ting Tang Night. One of Bathe's correspondents, Edith Spencer, wrote to him:

> My main interest was in 'Ting-Tang' Night, the night of the 23rd [December], when the old custom was for men to walk the streets banging on anything that would make a loud noise, mainly tin cans, iron pots and spoons etc. which they did to frighten away evil so that the town would be ready to welcome the Christ Child. Up to the end of the last [i.e., nineteenth] century this was undertaken annually, a procession of some importance apparently being formed... My aunt told me of this custom, in which her brothers joined at one time. I believe the ditty was
>
> Ting Tang Night
> Stars are bright
> Every little angel's
> dressed in white.'[9]

A photograph taken in the grounds of Winster Hall in the 1860s when Victorian antiquary and journalist Llewellyn Jewitt was in residence has been claimed as the oldest photograph of a group of mummers in the world – although locally in Derbyshire (as in Scotland and Northumberland), the term 'guisers' is much more likely to be used (stemming from the act of dis*guising* yourself with costume). In 1980 a group of Winster residents decided to revive guising locally, recreating their costumes from the old photograph, and the group has performed a short play in the weekends leading up to Christmas ever since across Matlock, Matlock Bath and the White Peak villages, raising much money for local charities in the process. One of the instigators, Dave Bathe (originally an Essex man who moved to the Matlock area to take a job at Derbyshire County Council's Planning Department), conducted extensive interviews in the 1980s with local elderly residents who remembered visits from the guisers during their youth in the early twentieth century (guising was largely killed off by the First World War when a generation of young men who would have been participants went off to fight, many never to return). Sadly, Dave was killed in a car crash at Edensor in 1992. His archive of research is now kept at the University of Sheffield Special Collections department, a wealth of information regarding local customs and tradition.

9 University Of Sheffield Special Collections, Dave Bathe Collection, ACT/97-003/1/1/155: Edith Spencer letter, 20 March 1982

 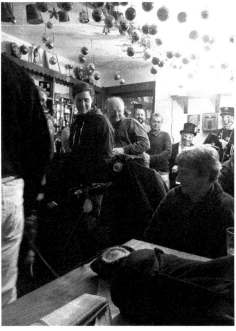

Above left and right: Winster Guisers performing at the Thorn Tree Inn, Matlock, 2014.

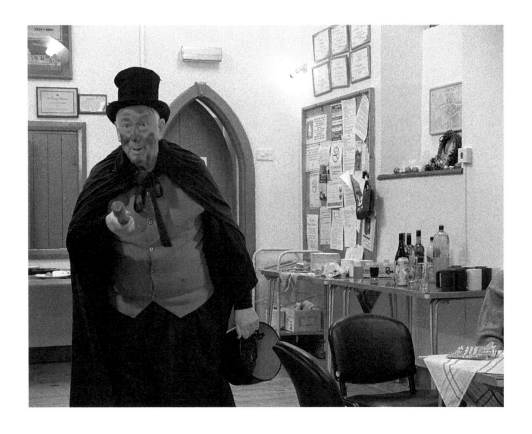

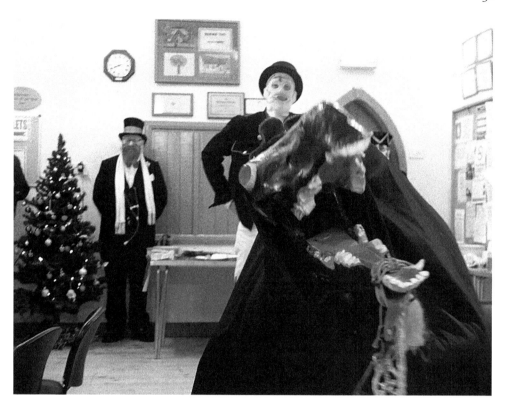

Above and opposite below: Winster Guisers performing at Elton Village Hall, 2017.

While the Winster Guisers enact a St George mumming play for our viewing delight, guising could consist of a simpler performance of Christmas carols while donning improvised fancy dress. There were elements to this, one being that the performers genuinely did want to disguise themselves in an era before paid annual leave, but when begging was viewed by some as a shameful practice. The second aspect was to lend a ritual, magical aspect to the proceedings (householders were sometimes invited to guess the participants, and expected to give out festive fare in the manner of trick or treating if they failed to do so).

Bathe's Archive contains some wonderfully vivid recollections of visits from the guisers in the Matlock District. Ninety-year-old Hilda Shepherd of Holloway remembered,

> it would not be Christmas until the guisers had been. I can remember them coming in the house from the age of four. There would be six of them all dressed in greenery ... Holloway was very small then and they were able to visit every cottage, with a lantern on a stick ... It is mostly woods round Holloway, and their hats and clothes were covered in greenery. They used to carry a long broomstick and that was covered in greenery too.[10]

10 University Of Sheffield Special Collections, Dave Bathe Collection, ACT/97-0031/1/192: Hilda Shepherd letters 4th February; 1983/23rd February 1983

Once the Holloway Guisers had gained entrance to the house, they would perform wassailing, singing, a St George play and a jig.

Not everyone was a fan of the guisers and their festive frolics, however. The author of the 'Matlock Gossip' column in the *High Peak News* of 29 December 1883 wrote acidly,

> There have been several bands of 'guisers' parading about during this festive season. From what I have seen of them, these men are the very embodiment of insolence. They are generally men of a stamp who are too idle to work, and under the disfigurement of their costumes think they have a right to exact comments from everybody they meet. It is quite optional with you whether you assist them, but if you decline you are treated to a shower of abuse which you little dreamed of. The sooner these imposters are run to earth the better for all parties.

A description of the guisers of Wirksworth printed in the *Derbyshire Times* of 28 December 1872 described their 'regalia', the costumes 'in some cases consisting of paper adornments, such as stars, and high pointed caps covered with stars'. The correspondent noted, 'It is very entertaining to listen to these "paper" youngsters'. They performed a St George play after which ladles were distributed to spectators and the following rhyme recited: 'My Father's a blacksmith, My Mother's a weaver; If you've anything to give, I'm the receiver.'

The writer went on to note that in recent years the paper costumes had been dispensed with, 'and instead of the former good order maintained over the sport, roughness and mischief enter largely into the game, masks being worn, faces blackened, and female garments adopted by some the performers ... they are a terror to orderly people, who are often insulted by them'. The guisers were such a part of the fabric of Christmas life in the town that as part of a Christmas open day at Wirksworth Chapel Lane Council School in 1933 the teachers had made a model of Wirksworth's market square 'with the guisers out on Christmas Eve'.

At Christmas Time the Darley Hillside Singers formerly also went out house-visiting. Methodism was established in the area by the 1820s, with music forming a big part of the worship from the beginning. By the mid-twentieth century, four tours of the Darley Hillside district took place, the carollers visiting everyone from the local farms and working-class railway and quarry workers' terraces to large mansions. Songs were sung unaccompanied and consisted of well-known festive favourites such as 'Silent Night' and hymns and carols particular to the locality such as 'Capy', 'Confidence' and 'Tenderly Sleeping' (collected by Russell (2012)). By the 1980s the four tours had downsized to one tour on the Sunday before Christmas, which, owing to an ageing congregation, became unsustainable, the last one occurring in 2007. Darley Hillside Methodist Church closed down in 2017, the congregation transferring to Dale Road Methodist Church, Darley Dale.

In the late 1940s, local newspaper the *Matlock Mercury* helpfully produced at least two volumes of *The Matlock Christmas Annual* to get townspeople in the festive spirit. Introducing 1949's volume two, the paper's founding editor Ella Smith hoped, 'To those who feel that [the annuals] are worth preserving these should someday provide an interesting historical record'. Studying them from the perspective of seventy years later, I can confirm Smith's wish came true, as they give a valuable flavour of life in the Matlock area in the immediate post-war era. In an age before Facebook, the *Christmas Annual's*

Above: Darley Hillside Methodist Chapel, former home of the Darley Hillside Singers.

Right: The Matlock Christmas Annual, 1949. (Reproduced with kind permission of John Roper)

'Matlock Overseas' column was a good way to keep up with how expats from the area were getting on, townsfolk and villagers having ended up in such far-flung corners of the world as Kenya, India, Canada and New Zealand. Dora Wildgoose (née Walker), former employee of Matlock Cinemas Ltd and later the Starkholmes postmistress, by 1949 living in South Rhodesia (today's Zimbabwe), wrote in to gloat that she 'loves the life, sunshine and lack of austerity'.

A photographic round-up of the 'outstanding events in the Matlock district during 1949' conveys the sense of life gradually returning to normal again after wartime – pictured are the reopening to the public of the Whitworth Institute in Darley Dale after its requisition by the army during the conflict; the much-delayed opening of Tansley's smart new primary school following its wartime use as a district food store; and the dedication of the Whitworth Institute cenotaph plaque on Armistice Sunday in November. Other events included the Matlock Bath, Cromford and Matlock Carnivals (where during the latter at the Baby Show 'Hundreds of perspiring mothers with their bonny offspring invaded the Town Hall'); the South Peak School's Sports Day; a September swimming gala at Matlock Lido (pictured are the ladies and junior girl entrants but the boys were 'too shy' to pose for the newspaper cameraman); and the Matlock and District Young Farmers' Ploughing Match in October.

In the heyday of the Hydros, it was the custom at Smedley's for the hard-working staff, who worked seven days a week (with a day off every three months), to sit down to a lavish Christmas dinner on Christmas day and be waited on by the guests who were staying over Christmas. Lilybank Hydro also maintained this practice.

After the excesses of Christmas Day, what better way to blast away the cobwebs on Boxing Day morning than donning a fancy-dress costume and taking to the chilly waters of the River Derwent on a self-built craft as an entrant in the Matlock Boxing Day Raft Race. The competition, organised by the Derbyshire Association of Sub Aqua Clubs, has been taking place since 1961, and raises money for the Royal National Lifeboat Association through entry fees and collections along the route – well over £150,000 to date. Crowds of thousands annually line the banks of the Derwent, with some walking along the river from Matlock and through Matlock Bath to the finishing line at Cromford Meadows to follow the action. Spectators get whipped up by the raucous atmosphere, bombarding rafts with flour bombs, while competitors give as good as they get, retaliating with water guns and flicking river water onto spectators with their oars.

As well as these many and varied annual events, the area has also supposedly been home to a variety of colourful beasts and fantastical beings over time.

A 'boggart' is a north country word for a ghost, which could take many forms: a traditional spectre, a ghostly black dog or even a real-life but slightly creepy local eccentric, crochety or elderly loner given the name so that children give them a wide berth.

When the large-scale redevelopment scheme for a Sainsbury's supermarket and housing on the Cawdor Quarry site at Matlock Bridge was announced in the mid-1990s, as part of the planning process it received a number of letters from members of the public both in support and objecting to the proposals. Those who objected did so for a variety of reasons: concerns about the increased traffic on the narrow roads of the villages of Starkholmes and Snitterton; disturbance to the resident wildlife population; the effect the superstore would have on the town's independent shops; the potential for increased

littering along the banks of the River Derwent; and a member of Matlock Cycling Club was concerned that the redevelopment of the access road would mean that the club might no longer be able to hold 25-mile time trial events, as previously they had used Crown Square roundabout as a turning facility.

The most surprising objection came from someone wondering what effect the development would have on the Standbark Boggart, who was apparently resident in the quarry, warning of dire consequences should it be disturbed. In spite of the various objections, the development went ahead, so if you're ever shopping in Sainsbury's and feel a cold chill come over you (and you're not in the freezer aisle at the time), it could be the wrathful boggart.

Stanley Jackson Coleman relays the story of the Mad Dog of the Jughole Caves, as told in old mining records. In the mid-nineteenth century, miners were prospecting for lead in the caves but the sound of a monstrous ghostly dog barking frightened them away. A party of intrepid early twentieth-century rock climbers upon later entering the caves discovered that the ghostly barking dog had a speleological basis, witnessing a shallow lake in the cave system emptying and refilling, creating the 'barking' sound that was amplified around the cave system by the natural acoustics (a similar phenomenon is the reason the Peak Cavern at Castleton acquired its alternative name of the 'Devil's Arse': the sound produced by the water there thought to resemble the noise produced by Satan's bowels).

Another spectral animal unearthed by Coleman was a phantom horse – never seen but only ever heard travelling at full pelt – on a lonely stretch of road near Tansley Moor known to locals as 'The Galloping Spot'.

Cawdor Quarry, former lair of the Standbark Boggart.

Jugholes Cave, former home to the Mad Cave Dog and Matlock's dragon.

Outside Winster in 1897, a remarkable creature was shot and killed, as reported by the *High Peak News* of 26 June 1897:

EXTRAORDINARY CAPTURE AT WINSTER: A TOMCAT WITH WINGS
The most interesting item in natural history, so far as the Matlock district is concerned, transpired this morning (Friday). Our reporter learns that Mr Roper of Winster, while on Brown Edge near that village, shot what he thought to be a fox, which had been seen in the locality some time previously, on Mr Foxlow's land. Thinking he had missed his aim, Mr Roper gave up the quest, but returning later he found he had killed the animal. It proved to be an extraordinarily large tomcat, tortoiseshell in colour with fur two and a half inches long, with the remarkable addition of fully-grown pheasant wings projecting from each side of its fourth rib.

Unfortunately, the climate having been so excessively hot, the animal was allowed to putrify, and after being generally exhibited all round the district the carcase has now been interred. It was seen by ... ample witnesses, so that there is no doubt the museums have missed a most curious animal.

A couple of local place names hint at the former existence of wild cats in the area. These creatures were once native to the British Isles, but now only an isolated population exists in the Scottish Highlands. Winster has a 'Wildcatthole' recorded by the year 1299, and

Postcard showing Two Dales'
'Fairy Glen'.

Matlock Bath has Wild Cat Tor, which towers over the Lovers' Walks. 'Big black cats' of
panther size have been sighted in the Carsington and Wirksworth districts in recent
times. In 2009 Adam Gladwin of Matlock saw one near Whitworth Park, Darley Dale,
while cycling to work at 5 a.m., and they have also been seen in the Northwood area.

In a comprehensive and otherwise fairly dry three volume work of 1811–17, *General
View of the Agriculture and Minerals of Derbyshire*, John Farey provides a short but
fascinating section covering the 'Customs, Opinions, Amusements, &c. of the People' of
the county. Here he reports, 'I was myself gravely told, in Tansley, that fairy elves are still
frequently heard to squeak, in the damp cavities of the Rocks, over which the water-fall
in Lumsdale is projected'[11]. So if ever you find yourself by the waterfalls in the Lumsdale
Valley – a former hive of industry now largely reclaimed by nature – listen carefully.

11 Farey (1817), p. 627

Perhaps the sylvan scenery that Matlock and district abounds is conducive to this long-lasting belief in fairies. I lived at Two Dales from age twelve to nineteen, but wasn't aware that there was a local 'Fairy Glen' until recently when I found an old postcard depicting it at the Matlock Antiques Centre (No. 169 published by the Loca-Vu Photo Co. of Sheffield).

Farey was also informed by Matlock citizens he encountered on his travels through Derbyshire that young children of the district were made to 'stare and tremble' by reports from older relatives about the exploits of the town's resident dragon. Schoolteacher and local historian Ernest Paulson wrote that when he taught in Matlock, he was asked by every form each year whether there was a monster under Masson. This is a variation of the story of the dragon defeated at Winlatter Rock near Chesterfield, as published in Ruth Tongue's *Folk Tales of the English Counties*. Paulson set the Matlock variation of the dragon down in writing, including local flavour of the defeated dragon going to ground in the Jughole Cave (the same one inhabited by the Mad Dog), where the fiery breath he breathes during his exile there is responsible for the warm thermal springs of Matlock Bath, and flames, which shoot out of the hillside at Riber, disturbing the rocks. When he thrashes his tail it causes earthquakes at Winster (a reference to the Winster Tremors, a series of small earth shocks experienced by the village in 1952).

Tongue also includes the story of Crooker (according to her collecting notes, 'Heard in 1927 at a picnic on Massen [*sic*], Matlock'), a terrifying malevolent being who stalks the road to Cromford beside the 'Darrent' (River Derwent), preying on unwary night-time travellers.

Benjamin Bryan, author of *Matlock Manor and Parish*, recalled from his childhood days a relation warning him of another monster that lived at the bottom of the River Derwent, who went by the name of 'Iron Teeth and Bloody Bones'. An unpleasant character named Tommy Rawhead and Bloody Bones was a mythical child-catching goblin of English and American folklore first recorded in the sixteenth century, and 'Iron Teeth and Bloody Bones' seems to be Matlock's own local variant. These particular old folktales have a practical function, the same one as *The Spirit of Dark and Lonely Water*, the notoriously terrifying 1973 public information film voiced by Donald Pleasance: that of frightening unsupervised children away from playing near potentially unsafe water sources.

If all this talk of winged cats, dragons and squirrel hunting has left you in need of a stiff drink, then your best bet would until fairly recent times have been to head out to the outlying villages, where you could sample some unique cocktails.

The Red Lion Inn at Wensley was one of my 'locals' growing up, although I now regret that I don't remember ever visiting; the pub closed down in 1998 (the year I reached legal drinking age) and now sits rather forlornly by the roadside. The fact that the pub had a farm attached was a key factor in its house special: 'Milliguinness' (or 'Milliguin') – one part Guinness to one part milk, fresh from the farm cows! The eccentric establishment, which also served fresh milkshakes and hosted regular spoken word poetry evenings, was kept for just short of half a century by brother and sister duo George and Barbara Bellfield from 1949 until its closure.

While the Red Lion sounds like it largely existed in a sort of mad timewarp, in other respects the Bellfields were ahead of their time, instigating a smoking ban in the pub as

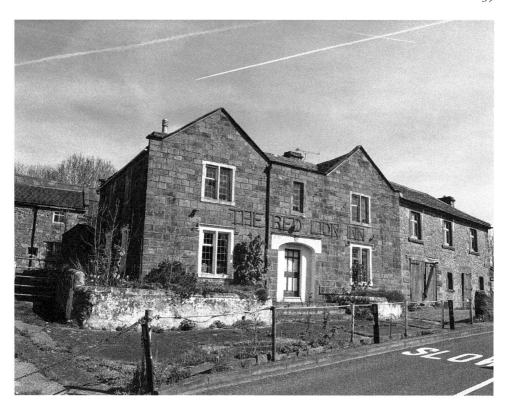

'Mine's a Milliguinness': the eccentric, and closed, pub The Red Lion Inn, Wensley.

early as 1968 in protest at having to collect frequently rising taxes on cigarettes for the government. Swearing was also banned within the pub. My schoolfriend Jonathan Francis of Winster remembers, 'They threw a friend of my Dads out in the 1970s for holding hands with his wife,' adding, 'The landlord stood for the Parish Council and received one vote, which was his own. Even his own sister didn't vote for him'.

A little further up the road, Elton village was home for many years to Blackpool-born Alf Gregory (1913–2010), official photographer of the successful 1953 Mount Everest expedition. A blue plaque marks his former home. The ageing process didn't dim Alf's intrepid nature, as he emigrated with his wife Sue to Australia in 1993 at the age of eighty to explore a new continent. *The Independent*'s obituary of 10 February 2010 noted that visitors to Alf at Elton could expect to be welcomed with an 'Eltonian', an extremely strong gin cocktail of Alf's own devising.

5. Matlock Modern School and the Kibbo Kift Connection

I first read about the Kibbo Kift, a group of renegade scouts from the early twentieth century who were subsequently confined to the obscurer, dustier corners of British history, in the early 2000s. I was immediately fascinated by this movement led by John Hargrave, aka 'White Fox', particularly their half-futuristic, half-rustic uniforms. An enthusiastic leader in Baden-Powell's scouting movement, Hargrave had broken away and set up his own organisation after feeling increasingly at odds with Baden-Powell's pro-imperialist stance and zealous Christianity.

Formed in 1920, the Kindred of the Kibbo Kift – named after an archaic piece of Cheshire dialect meaning 'proof of great strength' – later mutated from a scouting group into a full-on political movement in the tense atmosphere of the 1930s, the 'Green Shirt' Party (in opposition to the more widely remembered Fascist Black Shirts led by Oswald Mosley, and the Communist Red Shirts). The Green Shirts advocated a radical (and complicated) new system of economics called 'Social Credit'. To get their message across, they developed an array of audacious publicity stunts. These included throwing a green-painted brick through the window of No. 11 Downing Street, firing an arrow into No. 10, painting a giant green square on the Bank of England, and driving a dummy representing the governor of the bank around nearby Throgmorton Street, an act which so enraged a group of passing bankers that they tore the dummy from the car and destroyed it.

The outbreak of the Second World War quashed the momentum of the Kibbo Kift somewhat, and they spent the remainder of the twentieth century languishing in obscurity. Since the 2008 banking crisis, historians and commentators have begun to re-evaluate their significance. Some of their ideas seemed to increasingly resonate in a world that is still feeling the repercussions of the events of a decade ago. In 2015–16, the Whitechapel Gallery in London hosted an exhibition about them, 'Intellectual Barbarians' (it was an apt choice of venue, as the Kift themselves had staged an exhibition of their regalia there in 1929 in a bid to promote their ideas).

While reading a copy of the tie-in book *Designing Utopia: John Hargrave and the Kibbo Kift* by Dr Cathy Ross of the Museum of London (where much of the movement's archive is now kept), which I had received as a birthday present, I was surprised to unexpectedly come across a reference within its pages to Matlock. The Matlock Modern School, writes Ross, effectively became the Northern Headquarters of the Kibbo Kift (Hargrave lived in Kings Langley, Hertfordshire). Followers of the movement from North Derbyshire and nearby Manchester formed themselves into the High Tor Tribe, named after the well-known scenic crag located at Matlock Dale, between Matlock and Matlock Bath. Cathy kindly shared her working notes with me, which she had taken from the 'Log of the North Folk'. This journal, now preserved at the museum, detailed the activities of the High Tor Tribe across Derbyshire. It documents the Tribe attending a conference of the

Old postcard view of High Tor, showing Tor Cottage on right.

Economic Freedom League held at Hope in 1927. The following April, the League staged another conference at Matlock Modern School at which the enigmatic Hargrave gave a keynote speech, dressed in full Kift regalia. Throughout 1927–28, hikes were held from Bamford, Tideswell, Peak Forest, Kinder Scout and Grindleford (the Kift were very keen hikers; it must have been a startling sight to unexpectedly chance upon them out and about in the Derbyshire countryside dressed in their hooded cowls and brandishing staffs carved to resemble Native American totem poles).

An early and enthusiastic northern recruit to the movement in 1921 was a youthful Crichton Porteous (at the time living at Chorlton-cum-Hardy, Manchester, but later to move to the Matlock area and forge a career as a writer specialising in Derbyshire subjects – *see* 'The Matlocks on Page and Screen' chapter). The front page of Porteous' diary for 1922 is inscribed, 'C Porteous /22 (Kibbo Kifter)'. Porteous was aged twenty-one at the time, and in an entry that displays the characteristic existentialism of youth (beginning, 'What am I really after?') he exhibits hero-worship for Hargraves, writing, 'John Hargraves is a popular amalgamation of [Dr. William Gordon Stables, adventure fiction author and Richard Jefferies, nature writer]. Neither so great nor so gifted, yet a man of a vision, and greater thought – a man of an unflapping faith in his vision, a

fire to pass it on, unafraid of laughter. To become like him I must have faith, be fearless, and work, ready to sacrifice all.'[12] However, Porteous left the movement in 1926 and was subsequently critical of the group.

Mumming plays were staged at Matlock, written by a teacher at the school, Joyce Reason, a prominent member of the Kift who took on the clan name 'Sea Otter' and who formed the main point of contact between the organisation and the school. Reason (1894–1974) would later go on to pen a number of works of historical fiction aimed at young readers including *The Mad Miller of Wareham*, *Bran the Bronze-Smith* and *Dwifa's Curse: A Tale of the Stone Age*, as well as biographical accounts of various missionaries, travelling to East Africa in the role of editorial secretary for the Leprosy Mission. Joyce's great-nephew Matthew Reason, Professor of Theatre at York St John University, told me 'My understanding is that Joyce was viewed with some suspicion by the older members of the family, but with more curiosity from the younger members. She was of a generation of women whose lives were severely disrupted by the First World War and who never married, making their own way in the world and in work.'

Having myself attended secondary school in Matlock, it was exciting to imagine this enigmatic band of visionaries being active in the town seventy years before – a hitherto undocumented aspect of the town's history.

The earliest issues of *Derbyshire Countryside* (the Journal of the Derbyshire Rural Community Council and precursor to today's glossy *Derbyshire Life* magazine) from the 1930s ran recurring adverts for Matlock Modern School, illustrated by a bold woodcut depicting a futuristically dressed pair of girls joyously leaping from the abstract clutter of the city into the replenishing sunshine, hills and pine trees of some typical Matlock scenery.

I tracked down an old prospectus for the school in a bundle of material from Marchant Brooks & Co., a former Matlock auctioneers based on Causeway Lane, kept at the Derbyshire Record Office. Judging by its pitch, the Matlock Modern School, overseen by Principal Bertha Law and described as 'a residential school for girls and young boys', seemed to be geared towards the more sensitive child. The prospectus advised, 'many girls quite healthy and of an intellectual temperament are highly sensitive and refined, and for such the ordinary school methods with large classes are quite unsuitable and often a great strain. For these this school, with comparatively small numbers, and a fully qualified staff, is eminently adapted.' Pupils were encouraged to go on to take Oxford and Cambridge entrance exams, but only 'where their parents assent and their health is not in danger of being thereby impaired'.

In the context of the period that the school – and the Kibbo Kift – came into being, this sense of cosseting is to a degree understandable. The country had just been through the shattering experience of the First World War. Writers, artists and philosophers were all engaged in contemplating new ways of thinking about the world to ensure that such a catastrophe could never occur again (sadly, they failed, as within another quarter of a century it did).

12 Derbyshire Record Office Crichton Porteous Collection D6550/1/2: Porteous diary for 1922

MATLOCK FOR HEALTH.

Matlock Modern School

Opened by Sir Henry Hadow, Vice-Chancellor, Sheffield University, 1926.

RESIDENTIAL. 700 ft. up. South Aspect.

PRACTICAL EDUCATION for GIRLS and Young BOYS avoiding overstrain. Personal diets carried out. Perfect Health Record. Alpine Sun-Lamp. Public-speaking Class. Margaret Morris Dancing. Riding. Dramatic Work. Art and Handicraft Studios. Music. Matriculation. Qualified Staff.

Principal - - Mrs. ALBERT LAW.

WRITE OR 'PHONE FOR PROSPECTUS, 31 MATLOCK.

EDUCATION !

MATLOCK IS NEAR

and there is one of the BEST Boarding Schools in the Country there.

Matlock Modern School.

The Great Authority on EDUCATION :

SIR HENRY HADOW, C.B.E., M.A., D. Mus., LL.D., D. Litt., F.R.S.L. (Chairman of the Hadow Report on Education) writes "I shall be very glad to add my name to the list of Referees. I hope the School is continuing to prosper, as it thoroughly deserves."
SIR W. ARBUTHNOT LANE, Bt., C.B., M.S., F.R.C.S., the great authority on HEALTH, says—"A Wonderful School. This school is an example to others, in its ways and methods."

For Girls and Young Boys. Weekly Boarders Taken.

PERFECT HEALTH RECORD, ALPINE SUN-LAMP, PUBLIC SPEAKING CLASS, MAYARD MORRIS DANCING, RIDING, MATRIC, QUALIFIED STAFF.

Write for Prospectus or Booklet on Careers to
The Secretary, or Telephone 31 Matlock.

Above left and right: Adverts for Matlock Modern School. (Reproduced with kind permission of *Derbyshire Life and Countryside* magazine)

The school made much of its location in the prospectus, emphasising Matlock's fame as a celebrated health resort. Having initially operated under the name of Matlock Garden School from Tor Cottage at Matlock Dale (now the High Tor Hotel), the school bought the premises of the former Matlock House Hydro on Matlock Bank in 1924. The official opening ceremony of the new site was conducted by Sir Henry Haddow, vice chancellor of Sheffield University, on 11 March 1926. The prospectus gushed that the town was 'famous for its wonderful air, healthy and invigorating, being in the beautiful "Peakland" with its fine stretches of moorland and rocky scenery.'

Particular focus was placed on the students' diet, which followed the ideals of the New Health Society and consisted mainly of fresh fruit and vegetables, salads, fresh eggs and milk.

S.A.D. (Seasonal Affective Disorder), which affects many people during the winter months and is often treated with special light therapy, was only formally recognised and named as recently as 1984. Yet those modern thinkers at Matlock Modern School were thinking along these same lines sixty years previously, the prospectus bluntly stating that 'we receive too little sunlight in this country'. Consequently, under the guidance of Professor Leonard Hill ('the well-known scientist and authority on artificial sunlight'), a large sun-lamp was installed on the premises, which the prospectus proudly notes is the first such device employed in a private school, and led to a daily newspaper dubbing the establishment 'The Sunshine School'. The usual surname of the matron who operated this apparatus was, by a strangely apposite coincidence, Sister Light.

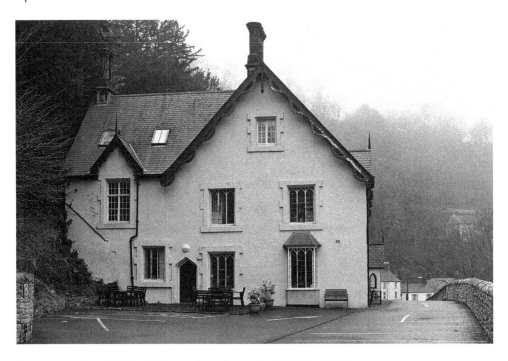

Former premises of Matlock Modern School, now the High Tor Hotel.

A strong emphasis was placed on the benefits of the outdoor life, with open-air classes consisting of nature rambles, swimming in thermal baths (presumably the Fountain Baths at Matlock Bath, as the New Bath Lido didn't open until 1933), horse riding, tennis and hockey. The school was keen on camping and had its own camping ground located nearby in an idyllic setting, 'on the hill-side among the pines, the bracken and the heather, with glorious views of the surrounding hills and dales of the Matlock country, so much beloved of Ruskin, Byron, and other poets and writers.' In addition students frequently elected to sleep outside in camp beds on the covered terraces of the school for several months of the year. The school also organised camping trips to France, Belgium, Holland, Switzerland and Italy. The pupils made their own tents and were encouraged to shop at markets and converse with local people in the language of the country to help build their self-confidence.

Particular attention in the school curriculum was also paid to the subjects of music and art as these were thought to have an 'ennobling influence in the formation of character' and result in 'a fuller realisation of life.'

The prospectus doesn't mention the Kibbo Kift by name, but a photo of 'An original play, depicting Mother Nature, Sun, Rain and Wind, and the little Human-kind' staged in the school's grounds shows a performer holding a staff and wearing a tunic with the Kift's insignia on it. Five other performers are dressed in various fantastical costumes, one sat on a throne. In the background of a photo of a studio room kitted out with looms and spinning wheel some totemic staffs can be seen propped up against the wall, while hung on the wall is a painting of five faces, some wearing hooded cowls, which has the distinctive insignia in the middle.

Matlock Modern School's second premises on Rutland Street.

By 1938, with the UK one year away from entering into global conflict again, Matlock Modern School entered voluntary liquidation, just twelve years after their move to a larger premises. Marchant Brooks handled the sale; hence the prospectus being preserved among their papers at the Record Office. It was not just the school that folded: Matlock's hydros were by this time also beginning to fall out of vogue. A solicitors' letter of 4 August 1938 to the owners of the school advises, '£1750 does not seem much for the property but it must be remembered that the hydros are passing through a very critical period and I don't think anyone but Smedley's would entertain the property'. Captain Douglas, the managing director of Smedley's, wrote on the 21 September 1938, 'My board have duly considered the offer contained in your letter of the 10th September, but are not prepared to give more than £1,500.0.0 free of all costs to them'. The building that had housed Matlock Modern School in its final incarnation was eventually sold to Mr E. H. Dakin of Matlock for £1,650. It is nowadays divided up into the 'Rutland Court' apartments. A blue plaque erected by the Matlock Civic Association on the gatepost remembers its previous incarnations as both the hydro and the lesser-known school.

Recent levels of concern over twenty-first-century children and youths suffering a disconnection from the world around them, termed 'nature deficit disorder', and rising levels of child obesity as a result of spending too much sedentary time indoors, have led to increasing numbers of Forest Schools being established around the country. Several local primary schools offer Forest School sessions on their curriculum including those at Darley Dale, Lea, Stanton-in-the-Peak, Brassington and St Joseph's Catholic

Blue plaque remembering the Matlock Modern School.

Academy in Matlock. The latter note on their website that 'Forest Schools originated from Scandinavia in the 1950s, the approach promoted outdoor exploration and encouraged children to understand their surroundings'. The story of Matlock Modern School, and the enigmatic Kibbo Kift who used the institution as their base in the North of England, is so little known that the academy appear unaware that just up the road from them (and a couple of decades before the Scandinavians got there), a forgotten group of early twentieth-century progressives were promoting a similar pioneering curriculum extolling the benefits of an outdoor life, healthy exercise and connection to nature.

6. Strange Things Found in Churches

We are accustomed to thinking of churches as temples of sobriety and upholders of society's moral codes. What, then, are we to make of an old stone carving at the clearly very ancient Church of St Helen's, Churchtown, Darley Dale? It is now worn and weathered as previously it was on an exterior wall, but with the building of a modern extension it now finds itself indoors. It is thought to be an example of a Sheela-na-gig, an ancient pagan fertility symbol of a woman exposing her genitals. Such figures do sometimes crop up in churches, and are thought to be a sort of PR exercise by the early Christian church, adopting some of the symbols of the older native pagan Celtic religions of the British Isles – however rude they may be – so as not to alienate their converts to the new religion too much.

Over at Brassington, on entering the Church of St James and looking upwards you are 'greeted' by a (very obviously) male figure making a point of spreading apart his buttocks while peeping over his shoulder and leering at you. The church guidebook notes gingerly

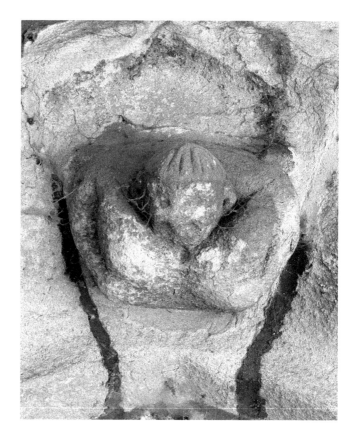

Sheela-na-gig, St Helen's
Church, Churchtown,
Darley Dale.

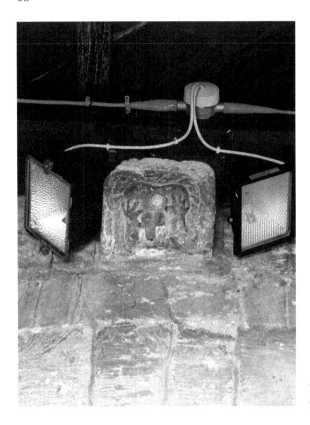

'Mooning' male figure, St James'
Church, Brassington.

that the carving 'suggests that our medieval forbears were more broadminded than us about what is suitable decoration for a church'.

Matlock's St Giles' has some touching survivals in the form of crantses or maiden's garlands. They have recently undergone conservation work thanks to funding from the Churches Council and one is now on display, albeit a little tucked away, in a glass case in the choir vestry.

On my visit to St Giles' for the Transport Blessing I arranged to photograph the ones in storage. Assistant churchwarden Brian Legood scrambled up a narrow ladder and retrieved three of the crantses for me to inspect, which are now kept in special archival storage boxes in the roof space – there's the sense of fetching the Christmas decorations down from the loft. They generate great interest among some members of the congregation, some of whom have not seen them before, or know what they are. Father John Drackley, former vicar of the church and an expert on its history, tells me that we know the practice of producing the garlands was obsolete in Matlock by 1838, and offers two theories as to why the custom died out. The first is that an evangelical curate took office around this time and took offence to such 'superstitious' objects being in a church, although fortunately they were not destroyed as elsewhere, but merely shut away in the cupboard. Drackley's second theory is that 'an old woman, or old man – more likely an old woman' in the parish was responsible for the making of the garlands, and was possessive over this role, refusing to share knowledge and experience

with anyone else. 'No, I make them,' asserts Drackley, assuming the character of this unnamed parishioner of days gone by. Upon their death, there was no one willing or able to continue to produce them.

DID YOU KNOW?

There is a reference to crantses in Shakespeare's *Hamlet*, when a priest states that Ophelia has been 'allowed her virgin crants' at her funeral.

The stored crantses are a shade of cigarette-ash grey and look like they could easily crumble to dust if you touched them or coughed too loudly next to them. One has a pair of paper gloves inside. The magpie Victorian antiquarian Thomas Bateman acquired a pair of garlands from Matlock for his private museum at Lomberdale Hall, and a 1911 *Folklore* article states that some from St Giles' Church had been sold as curiosities. Other local examples can be seen on display in the church at Ashford-in-the-Water.

There is a popular local legend that Birchover village migrated to its current location from the nearby hamlet of Uppertown. The current tiny St Michael's Church (built in 1717

Crants on dislay at St Giles'.

Above: Two crants normally kept in storage at St Giles'.

Left: Stone heads at Birchover Church.

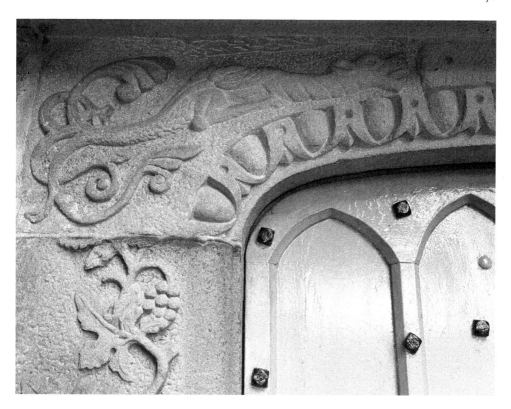

Dragon at Birchover Church.

and rebuilt in 1864) contains some ancient Norman stonework set into the exterior wall, including some carved stone heads, thought to have originated from a previous church located at Uppertown. The former village postmaster J. C. Heathcote was a keen archaeologist who kept a small museum of finds from the area at the post office, and recruited local schoolboys to assist with his digs, one of whom, Jim Drury, grew up to write a memoir of village life. Drury remembers the stone heads being stacked in the church porch and that the local vicar of the early twentieth century took offence at their pagan associations, so would turn them around to face the wall. Mr Heathcote would instruct his schoolboy disciples to turn them back facing the right way! Other Norman incised stonework thought to have come from the vanished church has ended up incorporated into the fabric of cottages around the village.

Above the door is a more recent carving of a dragon.

7. The Matlocks on Page and Screen

The wild scenery in and around Matlock and Matlock Bath has inspired both writers and film-makers as settings for their fictional worlds. Famous – and lesser-known – figures from the literary world have also visited, lived at, or grown up in the area.

Matlock Bath makes a cameo appearance in Mary Shelley's *Frankenstein* (although Shelley refers to it as Matlock, from the description it is clear that it is Matlock Bath that is being referred to). Victor Frankenstein passes through on the way to Scotland, having left his monster behind in Switzerland:

> We ... proceeded to Matlock, which was our next place of rest. The country in the neighbourhood of this village resembled, to a greater degree, the scenery of Switzerland; but every thing is on a lower scale, and the green hills want the crown of distant white Alps, which always attend on the piny mountains of my native country. We visited the wondrous cave, and the little cabinets of natural history, where the curiosities are disposed in the same manner as in the collections at Servox and Chamounix.

Authors Evelyn Waugh and Anthony Powell and film actor Dirk Bogarde were all enforced visitors to Matlock while on active service during the Second World War when they (separately) attended training at the School of Military Intelligence established in Smedley's premises for the duration of the war. Waugh was sent to Matlock in 1942 on a photographic interpretation course, a few days after the birth of his daughter Margaret. He wrote in his diary that the atmosphere at the school was relaxed with no suggestion of a military establishment, although uncomfortably overcrowded. While in the area he visited Matlock Bath, which he summarised as, 'a series of Lovers' Walks, cairns and petrified bowler hats'.[13] A nonplussed Waugh was informed by the 'custodian of the bowlers' that they were a popular feature for adorning garden walls of 'estates'. He was joined by his wife Laura in the third week of the course and the pair illicitly decamped to the New Bath Hotel.

Richmal Crompton (1890–1969), author of the Just William stories, was a pupil at St Elphin's Boarding School for daughters of the clergy at Darley Dale, relocating there in 1904 when the previous premises in Warrington were condemned. She would later return to teach at the school as the classics teacher. The former school buildings have been converted into the luxury Audley Village retirement complex, with further properties built in the grounds. The street name of 'Crompton Close' in the new development marks the connection with the famous writer.

13 Waugh (1976), p523

Reflecting a former pupil and teacher: Crompton Close.

Alison Uttley (1884–1976; born Alice Taylor), author of the Little Grey Rabbit stories for children, grew up at Castle Top Farm, between Cromford and Holloway. She attended primary school in the village of Lea and won a scholarship to Lady Manners School at Bakewell and subsequently Manchester University to read physics, where she was the second woman ever to graduate.

Reading through Uttley's published writings and diaries, a picture of a complex character emerges. In her published diaries, which are condensed down into a fifth of the actual written output, she frequently reminisces and dreams about being at 'dear old' Castle Top Farm, but never revisits Derbyshire following her move to Buckinghamshire. In spite of being a staunch Christian and having a rational scientific mind, she retained beliefs into adulthood that appear borderline animistic such as bowing to the new moon and making wishes on it, and feeling drawn to particular trees.

The fiction works of the writer Crichton Porteous (1901–91) are little read today. Born in Leeds and raised in Manchester, Porteous felt a strong affinity from a young age for farming, nature, the outdoors and the countryside. As a young man he attempted a city office job, but the experiment proved short-lived, and after four years he fled by bicycle for the Cheshire countryside where he obtained a job as a farm labourer. He was eventually to settle in Derbyshire, first at the hamlet of Combs near Chapel-en-le-Frith where his wife Ruth had grown up, and then in the 1940s the pair moved to the Matlock area, taking a house at Two Dales. He stayed here until his death almost fifty years later, and his name lives on in the village in the form of Porteous Close, a 1980s housing development close to his former home on Park Lane, which in recent years has itself been graced by a blue plaque marking his residency.

His novels are peopled with rustic folk and their everyday lives, leading to his publishers touting him as 'the Thomas Hardy of Derbyshire'. I set out to track down a copy of his 1960 novel *Toad Hole*; the copy in Matlock Library's Local Studies Store could not be located, but I managed to find one in Sheffield Central Library's Local Studies Store – according to the date label inside, I was the first person to borrow it since 1966.

Porteous Close, Two Dales.

Blue plaque on Crichton Porteous' former home.

Toad Hole was the original name of Two Dales, before it became prettified in Victorian times – incidentally, nothing to do with toads, but foxes, the settlement being recorded as Todeholes (fox earths) in 1590. Porteous' Toad Hole is a mixture of the fictional and factual: set in the valley of Gammel Dale (recognisably Darley Dale for anyone who knows it) by the River Darrent (Derwent) and famed for its nurseries. Chatsworth, Rowsley and Over Haddon are all mentioned, and a newly-wed couple travel by horse and cart over the moors to an unnamed market town, which, with its crooked spire and reference to the Falcon Inn and Low Pavement, is clearly Chesterfield.

Porteous was a fan of D. H. Lawrence (more of whom shortly), and adopted one of Lawrence's traits of peopling his novels with thinly veiled versions of real-life people. One of the main characters in *Toad Hole*, the haughty, unpopular (though philanthropic) and above all wealthy industrialist Sir Joseph Delf is an outrageously blatant facsimile

of Sir Joseph Whitworth, who settled in Darley Dale at Stancliffe Hall. Exactly like Whitworth, Delf has amassed his fortune through designing a new kind of screw thread and rifle. Even incidental details like the fact that Delf's second wife is named Louisa and they both moved to the countryside from a villa in Manchester called 'The Firs' are copied and pasted verbatim from Whitworth's life. Whitworth's lawyers would presumably have been coming down heavily on Porteous had he still been alive at the time of the book's publication.

While Porteous is hardly troubling the bestseller lists these days, he at least has his own Wikipedia page, which is more than can be said for the super-obscure author Professor J. Fletcher Ray, who wrote the religious historical fiction novels *The Hand That Drove the Nails* and *The Garden of Gethsemane*. Ray lived at Huntbridge House, Matlock Green (now Red Cross House). His secretary, Hilda Bennett, in 1941 married New Zealand-born fighter pilot Vaughan Engstrom. Ray was extremely fond of him, treating him as a son. In 1943 Hilda gave birth to twin daughters, Barbara and Christine. Sadly, mere weeks later their father was killed while instructing a trainee pilot on a training flight in Leicestershire. Ray was devastated, and according to an online Amazon review of *The Hand That Drove the Nails* left by Barbara, he left the royalties from both books to the twins.

One of the giants of twentieth-century literature lived in enforced exile in the Matlock area for a short period. D. H. Lawrence (1885–1930) grew up at Eastwood in the neighbouring county of Nottinghamshire. Lawrence frequently drew from the people and places around him to create his fictionalised world, and knew Derbyshire well.

In 1915, Lawrence and his German wife Frieda (cousin of Manfred von Richthofen, popularly known as the 'Red Baron') moved to Zennor, on the Cornish coast. The Lawrences were very happy here, but unfortunately for them, Britain was at war with Germany at this time. The Cornish locals viewed the couple with suspicion in the tense atmosphere of the time, and the pair were ultimately evicted from their home in October 1917 under the Defence of the Realm Act by the authorities, suspected of spying for Germany (their habit of loudly and provocatively singing German folksongs while taking hikes along the Cornish cliff paths did not do much to help their cause). In an indication of the national sense of paranoia, the Lawrences were accused of hanging out their washing in such a fashion as to send coded messages to any passing German submarines!

Now banned from living by the coast, the couple drifted aimlessly between addresses in London and Berkshire for a period of six months. Lawrence's sister Ada, who lived at Ripley, came to the pair's rescue, generously offering to fund a year's tenancy (at a cost of £65) at the isolated Mountain Cottage, located just outside the village of Middleton-by-Wirksworth, 8 miles away from her own home.

Mountain Cottage is perched on a cliff side overlooking the wild valley of the Via Gellia. The valley road was cut through in the eighteenth century by the Gell family of Hopton Hall to better connect their lead mines and quarries. With its sharp bends, it was named as the second-most dangerous road in the UK in 2011, and the many overhanging trees can lend the road a gloomy aspect even at the height of a summer's day, adding to the sense of disorientation for drivers.

Coleman (1954) reports what must be one of the strangest local ghost stories, saying that travellers along this road (and their startled horses) have witnessed a headless calf

Old postcard of Via Gellia.

Lawrence in exile: Mountain Cottage (in centre of photo), viewed across the valley from Slaley.

rolling down the steep hillside, while Derbyshire writer and paranormal investigator Wayne Anthony (1997) claims that the woods have 'long been associated with black magic and witchcraft'. The Victorian ghost story writer R. Murray Gilchrist, in his short 1911 travelogue of the Peak District, writes with regards to Via Gellia, 'in May the traveller is assailed there by rustic children who offer bunches of greenish lilies of the valley'. Two of these 'rustic children' would grow up to set down on record their memories of childhood life in the area and remembered gathering and selling flowers plucked locally to passing motorists, thus corroborating Gilchrist's account: Edith Taylor (née Slack) (1996) and Hubert Doxey in *A Way of Life* (1997) (according to Doxey, the going rate was sixpence or a shilling a bunch; such an enterprise would nowadays be illegal under the 1981 Wildlife and Countryside Act).

The Lawrences moved to Mountain Cottage in May 1918. Not far into their tenancy, Lawrence sent Catherine Carswell a unique gift: a shoebox full of twenty different kinds of wild flowers including yellow rock roses, milkworts, mountain violets, woodruff and forget-me-nots – all hand-picked from in and around the grounds of Mountain Cottage.

Ible, a remote farming hamlet used by Lawrence as the setting for *Wintry Peacock*.

The flowers were carefully packed in damp moss and accompanied by a small floral guide, handwritten in tiny writing by Lawrence. On 20 December 1918, Lawrence sent the writer Katherine Mansfield a Christmas present, which he had bought in Matlock for her, a piece of fluorspar, described as 'this bit of the Derbyshire underworld ... mined just near – and cut in Matlock It is a golden underworld, with rivers and clearings ... For some reason, it's like Derbyshire'.[14] On this same visit to Matlock he had his hair cut and beard clipped, complaining that the barber 'shaved me bald and made me look like a convict'.

Here at Mountain Cottage Lawrence worked on his *Studies in Classic American Literature* and *Movements in European History*, as well as lesbian psychodrama *The Fox*, published in 1922. The piece of writing most influenced by his surroundings, however, was the short story *Wintry Peacock*. Lawrence's writing technique involved to a large degree fictionalising events, people and places around him, something which cost him several friendships. *Wintry Peacock*, apparently based on true events, tells the story of a soldier away abroad on service in the First World War who sires a child on the continent while his wife remains at home on his parents' farm. The story is set across the valley from Mountain Cottage in the tiny Derbyshire farming hamlet of Ible, but Lawrence covered his tracks by changing the name of the location – to 'Tible'!

In a 1978 *Derbyshire Life and Countryside* article, Betsy Innes-Smith visited Mountain Cottage and spoke to the then occupant, Miss Florence Kirk, who had lived there for the

14 Lawrence (1984), p309

preceding twenty-five years. Innes-Smith felt that were Lawrence and Frieda to visit the cottage in 1978 they would feel at home, as little had changed – the view across the Via Gellia remained unspoiled, and the cottage at this late stage still had no mains water supply nor electricity. Miss Kirk thought she may once in her youth have had a sighting of Lawrence, pushing his bike up Cromford Hill behind a band, remembering him as 'odd-looking' with his red hair, beard and shorts.

While Lawrence seemed to largely enjoy the bucolic isolation of Mountain Cottage, it is clear from reading his letters of this era that he was feeling cooped up and desperate to leave England, a country he felt largely rejected by. After the end of the war the Lawrences fled the country at the earliest opportunity, embarking on an itinerant existence until his death, travelling and living in Sicily, Sardinia, Sri Lanka, New Mexico, Australia, Italy and France. The towns and villages around Matlock clearly remained in his psyche, however. His novella *The Virgin and the Gipsy* [*sic*] was written in 1926 while the Lawrences were living in a villa near Florence. However, a few months previously, in October 1925, Lawrence had been back in Derbyshire where, accompanied by the ever-faithful Ada, he had embarked upon a tour of the area. His letters inform correspondents that he has been motoring around his 'native' Derbyshire, and that it was 'a very interesting county'. Another letter mentions that Lawrence had twice on this trip visited The Peacock at Rowsley.

The plot of *The Virgin and the Gipsy* concerns a vicar whose wife absconds, leaving behind the pair's two young daughters. The family (along with the vicar's brother, spinster sister and ageing mother) relocate from Buckinghamshire to a rectory in the north country, and the narrative commences after they have been established there some time and the two girls are entering early womanhood.

Confusingly, in the story the location of the vicarage is called 'Papplewick', which is a real-life Nottinghamshire village noted for its Victorian Pumping Station, now run as a working museum. The fictional Papplewick seems largely based on Cromford, however. As with Porteous' Toad Hole, the setting is a mixture of the real, the half-real and the imagined, with references to 'the Red Lion up at Darley', Tideswell Cattle Fair, Codnor, Heanor, 'Tansy Moor' (Tansley Moor is mentioned in a letter to a friend as being on the route of one of his favourite hikes from Crich to Matlock Bridge), 'Woodlinkin' (which resembles Stoney Middleton), 'Amberdale' and 'Bonsall Head' (recognisably Monsal Head, rather than Bonsall).

Matlock also makes a cameo appearance of sorts in Lawrence's most notorious novel, *Lady Chatterley's Lover*, written around the same time: 'When Connie saw the great lorries full of steel-workers from Sheffield, weird distorted smallish beings like men, off for an excursion to Matlock, her bowels fainted and she thought: Ah God, what has man done to man? What have the leaders of men been doing to their fellow men?'

Lawrence's work pushed at the boundaries for the time he was writing, supposedly leading to him being referred to as 'that mucky man' in his native Eastwood. When the permissive atmosphere of the late 1960s led to a relaxing of cinema censorship rules, Matlock and the surrounding villages found themselves playing temporary home to film crews descending on the area to shoot adaptations of his works.

DID YOU KNOW?

Towards the end of its life as a cinema, on 23 September 1996 Matlock's Ritz (opened in 1922 as the Picture Palace) hosted the world premiere screening of Franco Zeferelli's *Jane Eyre*, scenes of which were shot at Haddon Hall. Expectant crowds gathered on Causeway Lane, but sadly the film's stars all had prior engagements.

While it is mostly remembered for the infamous nude wrestling scene between Oliver Reed and Alan Bates, Matlock makes some cameo appearances in Ken Russell's 1969 adaptation of Lawrence's novel *Women In Love*. In the film's opening scenes, No. 80 New Street ('Hill View'), one of a pair of semi-detached villas built in 1888, is used for the exterior shots of the Brangwen sisters' house.

A scene that follows shortly afterwards, the wedding of Laura Crich to Tibby Lupton, was shot at St Giles' Church, while the Brangwen sisters (Glenda Jackson and Jennie Linden) frolic among the gravestones. St Giles' also played location to a funeral scene in 2004's unremittingly bleak *Dead Man's Shoes*, made by Sheffield's Warp Films and directed by Shane Meadows. The revenge drama explores the darker aspects of life in a small country town, and features other scenes shot in and around the town including out at South Darley, Bonsall, Tansley and Wessington, with the climactic scenes being shot up at Riber Castle.

No. 80 New Street, Matlock (top right), which was used as a film location for *Women in Love*.

Above: One wedding and a funeral: St Giles', cinematic location for *Women in Love* and *Dead Man's Shoes*.

Left: Abandoned petrol station at Wessington used as a film location for *Dead Man's Shoes*.

The Virgin and The Gipsy was also adapted for the cinema during the late 1960s period of new-found cinematic freedom (adopting the more conventional spelling of 'gypsy'). Filming took place at locations including Beeley Moor, with Youlgrave being used for 'Papplewick'. The film was made on a small budget, with extras being recruited from local streets and pubs and kitted out in 1920s clothes.

DID YOU KNOW?

The Virgin and the Gypsy was the first UK film to receive an 'AA' certificate, which was introduced by the British Board of Film Censors on 1 July 1970 and classed as a film suitable for those aged fourteen and over, a consequence of the decision to raise the viewing age for X certificate films from sixteen to eighteen. AA films could contain mild sexual and violent content, and moderate swearing. The classification was replaced by the '15' certificate in 1982.

The opening sequence was filmed at Cromford station on Monday 21 July 1969. The film company had arranged to run a steam train on the up line from Matlock to Cromford, which had recently been decommissioned a couple of months earlier on the 11 May when the line from Ambergate was singled. It is worth noting here – given that Apollo 11's lunar module *Eagle* had landed on the moon on the day before filming the station shots took place, and this was the end of the decade propelled by 'the white heat of technology' that the filming of this scene was taking place less than a year after the final run of a steam locomotive on active passenger duty in the UK, on 11 August 1968. Bearing this in mind makes it easier to understand how a man at Matlock station asked in all seriousness after the filming had wrapped and the steam train was sent back down the line to Matlock whether they were the train to Derby.

DID YOU KNOW?

George Newnes, pioneering publisher of *Tit Bits*, *Strand* and *Country Life* magazines, was born in 1851 at Glenorchy House, Matlock Bath. The house was demolished in the 1950s as part of a road widening scheme. Having gone off to make his fortune, Newnes retained links with the area of his birth, being a major investor in the Bank Road tramway scheme.

8. Trees, Plants and Stones

Our ancestors lived in closer proximity to nature, and consequently some trees, plants and stones were formerly revered and thought to possess certain properties. From the perspective of the early twenty-first century, some of these ancient beliefs have apparently lingered on in the Matlock area.

If you were paying attention during the Introduction, you will recall that my childhood years were spent growing up on Will Shore's Lane, Oaker. But who was Will Shore? His identity has become a little lost in the mists of time, but he has left the Matlock area with a prominent landmark. Will Shore's Lane leads on to Oaker Hill, where can be found Will Shore's Tree (marked as such on Ordnance Survey maps by 1888). According to local lore, Will was one of two brothers, and the tree was supposedly planted when his brother Peter decided to emigrate to America, one of a pair planted by the brothers to mark their parting. The ambitious Peter's overseas schemes are said to have come to nothing and his tree symbolically withered away, while Will remained in the Matlock area and flourished, as did his tree. The story attracted the attention of the poet William Wordsworth, who was staying at Snitterton and could see the tree from his window. Asking his landlady about it, he was apparently told the story, and was moved to pen the poem 'A Tradition of Oker [sic] Hill in Darley Dale, Derbyshire'. However as with all good folklore, there is a rival theory, which is that Will Shore planted his sycamore tree on the hill to supply the wood for his coffin. Will has also been rumoured to have been connected with the family of Florence Nightingale of Lea Hurst. There is an impressive stone tablet in Bonsall Church with the name Will Shore on it – is this our Will?

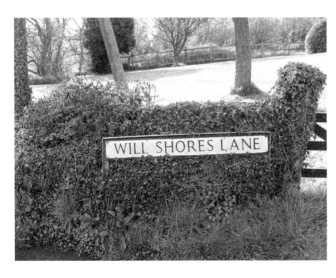

Will Shore's Lane, Oaker.

Right: Will Shore's Tree, Oaker Hill.

Below: Old postcard view showing Will Shore's Tree.

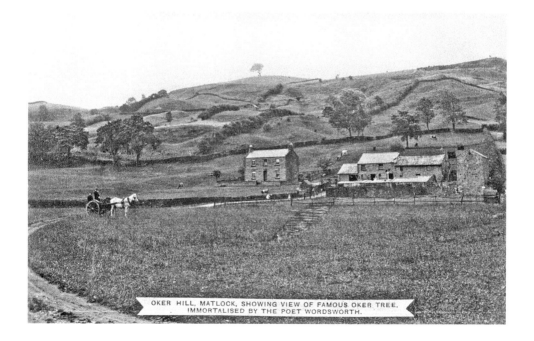

OKER HILL, MATLOCK, SHOWING VIEW OF FAMOUS OKER TREE, IMMORTALISED BY THE POET WORDSWORTH.

In the shadow of Will Shore's Tree, in the churchyard of the clearly very ancient St Helen's Church, Churchtown, Darley Dale, the Darley Yew can be found. The age of this tree, whose trunk has an impressive girth, has been the subject of some debate, with 2, 000 years old being put forward. In 1863, the editor of *The Times* received a letter purporting to be written by the Darley Yew bemoaning the fact that sightseers persisted in carving their names on its bark and cutting off branches as souvenirs, a phenomenon which had begun with the increase of day trippers to the area since the opening of Darley Dale railway station in 1849 (it closed in 1967, a victim of the Beeching cuts, but was subsequently reopened in the 1990s as a heritage steam railway by Peak Rail). A supportive letter was printed a few days later purporting to be from the two trees planted by the Shores on Oaker Hill. In the winter of 2017–18, the yew played host to a flock of around twenty-five hawfinches, a species on the RSPB's Red List of birds with the highest conservation priority.

Since the early 1800s The Matlock area has been home to several nurseries. The Smiths established their business from the small hamlet of Slack on Slack Hill before two branches of the family split off to establish large nurseries at Darley and Tansley (both still in operation, as Forest Nurseries and Scotland Nurseries, respectively).

The Darley Yew.

Old postcard view of the Darley Yew.

COPYRIGHT
D.D. 6.

TRUNK OF OLD YEW TREE, DARLEY DALE.

LILYWHITE LTD.,
TRIANGLE, HALIFAX

Siberia Cottages (former location of Siberia Nurseries) – in sub-Siberian conditions.

An 1893 tourist brochure remarked that James Smith & Sons Nurseries at Darley Dale 'make a charming excursion from Matlock, and should on no account be missed by the visitor who has an eye for the beautiful'.[15] Rhododendrons were a speciality of the firm. The hillsides around Darley Hillside and Sydnope were colonised by individual nurseries that each specialised in particular plants: Home Nursery (conifers and hardy herbaceous plants); Station Nursery (Austrian pines, ornamental willows, poplars and fruit trees); Canada Nursery (specialising in American plants including andromedas, cranberries, white fruited bilberry trees); Wheatley Nursery (hollies and conifers); Hall Dale Nursery (ornamental trees and shrubs, limes, hazels, Spanish chestnut and box); Charlestown

15 Anon, *Famous Derbyshire Health Resorts* (1893), p. 26

Nursery (the rhododendrons, 'at least a million' of which were growing in 1893); Siberia Nursery (hardy forest trees and shrubs, including spruce and heathers); Roundhill Nursery (larches, ashes, birches, hazels, sycamore, laurels, Norway maples, privets, and black willows – grown for timber); and Hall Moor Nursery (larches, laurels, limes, spireas, privets, Indian cedars).

The nurseries took advantage of Darley Dale railway station. A 1900 catalogue for the firm has a table at the back listing freight charges for plants and trees sent from Darley to every railway station in Britain, from Aberdare to York (it is a shame for the sake of poeticness that the hamlet of Zouch near Loughborough never had its own station). A large packing shed for the nurseries formerly existed where Porteous Close is now located. The old nursery bell is now affixed to the nearby bungalow Clam Danel. In 1908 and again in 1911, thousands of trees and shrubs from the Darley Dale nurseries were sent over to Kaiser Willhelm II for landscaping the grounds of Potsdam Palace. Unsurprisingly, that particular order dried up shortly afterwards.

Several nurseries still exist on the hillside slopes of Hackney. My dad can remember driving over to Hackney from his family home at Glapwell near Bolsover in the 1950s with his mum to buy shrubs for their garden from the Gervais Smith nurseries, where they were taken out into the field and picked a particular specimen, which was dug up in front of them to take home.

Nurseries at Hackney.

Former nursery bell
on bungalow at Two
Dales.

While plants grown in the area have enhanced gardens all over the world, stone quarried locally has built countless buildings. Hopton-Wood stone from quarries at Middleton-by-Wirksworth has been used in the construction, renovation or interior decoration of some of the country's most iconic buildings including the Houses of Parliament, the Tower of London, the Bank of England, Winchester College, the carved panels on the Moot Hall in Wirksworth, *The Sower* sculpture by Eric Gill on the BBC's Broadcasting House, Liverpool Cathedral, Rugby School, Balliol College Oxford and Southwell Minster. Stone from the Birchover quarries can also be found within the fabric of the Houses of Parliament and Tower of London, as well as Windsor Castle. Sheffield City Hall is built of stone from the Darley Dale quarries. Stone from the Matlock quarries was used to build London's Savoy Hotel and in renovations to Nottingham Castle. That same 1893 tourist guide crowed, 'Post Offices, Revenue Offices and other public buildings are now, under the authority of HM Office of works, constructed largely of stone from Bentley Brook and Farley Quarries, as being more weather and wear-resisting, and at the same time affording the maximum protection for public documents etc., against risks from fire and other casualties.'[16]

Until very recently, it was possible for members of the public to visit the disused Hall Dale Quarry located on the road out of Matlock towards Snitterton, described by fossil hunting website www.ukfossils.co.uk as 'one of the best locations in Derbyshire ... You could spend days here, finding superb fossils'.[17] I visited with my young son Oscar and despite being total fossil-hunting novices, we easily managed to locate some loose stones with good examples of brachiopods in them. However, since our visit in 2016, a large and forbidding metal fence has appeared around the site making entry impossible, owing

16 *Ibid*, p. 23
17 https://web.archive.org/web/20170215234345/https://ukfossils.co.uk/category/derbyshire/

Hall Dale Quarry.

Examples of brachiopods found at Hall Dale Quarry, 2016.

to one of the many building developments that is currently taking place at a slightly alarming rate on the outskirts of Matlock.

The area around Matlock has clearly been colonised for thousands of years. The prehistoric stone circles up on Stanton Moor retain a ritual focus, being visited by people from all over the world, in particular the Nine Ladies. Other ancient monuments have sadly been lost over time, with some of these powerful shrines of our distant ancestors ending up smashed up to build drystone walls. Riber hillside was the former location of an ancient stone monument called the Hirst Stones, still in existence in 1822 as Ebenezer Rhodes refers to them in *Peak Scenery*, calling them 'not unworthy of a visit'. Naylor (2003) speculates that they may have been destroyed by Smedley when building Riber Castle as their pagan origins offended his Christian sensibilities. However, going against this theory, Riber Castle was built in 1862; writing the following year, Richard Hackett writes,

Druid's Chair from ancient
monument formerly on
Riber Hill.

On Riber Hill was formerly some large masses of grit stone, supposed to have been the remains of a druidical altar. It consisted of four rude masses of stone, one of which, computed to weigh several tons, was placed on the others, and on this formerly stood a stone pillar. They were destroyed, however, some years ago, for fencing, by a reckless individual, but a stone chair was preserved from the wreck by Mr. George Wall, and is now placed in his farm yard.[18]

This contradicts the Smedley theory, especially seeing as John Smedley is listed in the back of the book as one of its subscribers – hardly good public relations to refer to one of your supporters as a 'reckless individual'. The stone 'druid's chair' was on display at Riber Castle for some years, but when the wildlife park closed down it was rescued a second time, and along with its information plaque it is now safely ensconced in the grounds of a local house, whose owners kindly gave me permission to photograph it for this book.

Another of Matlock's lost ancient monuments was the Seven Brideron, or Seven Brethren, a large stone circle located on Matlock Moor in the vicinity of Matlock Golf Course. It still existed in the latter half of the eighteenth century, as antiquary Major Hayman Rooke sketched in his Derbyshire sketchbook, noting that it was 25 feet in diameter and contained seven stones. However, his contemporary, the Revd Samuel Pegge, placed it in a different area of the moor, close to Palethorpe Farm, and said there were actually nine stones. In a 1687 map of the parish boundaries for neighbouring Ashover, it is marked as a landmark delineating the border of the two parishes. Naylor (2003) suggests that the monument may have been simply quarried away.

Happily, one mysterious ancient monument remains on the golf course, in the shape of The Cuckoostone, which features as the club's logo, sported by its members on their ties and polo shirts. It has also lent its name to Cuckoostone Farm and Cuckoostone Grange

18 Hackett (1863), p. 182

Farm, just above the golf course. When the *Derbyshire Courier* newspaper's farming correspondent visited in 1911, they noted, 'The name of both places is derived from a large block of stone standing upon the hillside, and which from time immemorial has been known as the Cuckoostone, because, as everyone will tell you, the cuckoo invariably sits there and calls on her first arrival. The place is said to be constantly frequented by these birds, indeed a witness of the most unimpeachable reliability averred that he has seen two cuckoos on the stone at once, and that whenever visited in summer, cuckoos were always about the stone.'[19] While the cuckoo has seen a marked decline in the UK, Barry Gray in his 2006 centenary history of the golf club notes that cuckoos still returned to the dale, usually in the first week in April. When I visited the golf course in mid-April 2018 to photograph the Cuckoostone, a golfer who I spoke to who was just extricating his ball from the long grass around the stone observed that he hadn't yet heard any calling. However, an alternative origin for the stone's name derives from 'cock-crow stone', as the stone is supposed to turn around whenever it hears a cockerel crowing. This is actually a common legend ascribed to various ancient stones located throughout the British Isles.

The *Courier* report went on to speculate with a dramatic flourish, 'The original purpose of the stone is lost in the mists of antiquity, but, remembering the existence at Riber of stones of undeniably Druidical origin, it may very reasonably be conjectured that the Cuckoostone was formerly a sacrificial altar ... it is more than probable that the sheltered slopes now devoted to the absorbing but peaceful pursuit of golf were once the scene of dread processions of white-robed priests, drowning the cries of the victims with beat of drum and chant of hymn.'[20]

Whatever the area's previous use may have been, as with much of Matlock's expansion the creation of the golf course was spurred on by the hydropathic establishments, to appeal to their largely middle-class clientele. A consortium of owners spearheaded by Henry Challand, the chairman of Smedley's, mooted the idea in the early twentieth century, as they felt that it was an amenity that the town was lacking when marketing itself as a classy holiday destination. The hydros' resident doctors recommended that their patients take up golf for the exercise and the fresh air: an advert for the Lilybank Hydro promised that visitors 'will find the Golf most interesting, and the air of the moors very invigorating'.

As well as being a haunt for cuckoos and allegedly the site of druidic rites, Matlock Golf Course has played location to other surprising dramas over the years. In 1928, a Bristol Fighter Mark III piloted by a member of the RAF became lost in heavy fog above the town while conducting a training flight and crash-landed on the links, demolishing a dry stone wall. The pilot escaped largely unhurt, but the same unfortunately cannot be said for a man by the surname of Beresford employed around 1903 to investigate water sources to supply the town on land that shortly afterwards was ultimately to become the golf club. A cave-in occurred while the unlucky Beresford was digging, crushing him to death. Local legend has it that he is buried underneath the golf course; however, the less colourful facts are his body

19 *Derbyshire Courier*, 19 May 1911
20 *Ibid*

Above and below: The Cuckoostone, Matlock Golf Course.

was recovered and is buried in Matlock churchyard. A metal stake in the rough bushes to the right of the fifth hole roadway marks the site of the accident, however.

The sixth hole passes by Cuckoostone Farm. Barry Gray reports in the early years of the course the farmer's wife Mrs Nicholls could often be spotted hopping over the drystone wall of the farm with a small bagful of hickory golf clubs and having a quick knockabout. The farming family also capitalised on their proximity to the course by selling homemade lemonade over their wall to thirsty golfers on hot summers' days. The ninth hole had to be played with care as a stray shot over the wall was likely to land in the farm's piggery.

Nearby, by a footpath at Lumsdale the 'Wishing Stone' (formerly known as the Broad Stone) can be found, a large gritstone boulder that according to local lore has the power to grant wishes. It was a popular destination for guests of Matlock's hydros to visit on walks; a small ornate shelter, which was formerly next to the stone, has been resited on the Chesterfield road near the golf club. We can well imagine that, with nothing to lose, those visitors in a state of imbalanced health would have employed it to wish for a recovery in addition to the treatments they were receiving. My schoolfriend Katie's family home on Matlock Bank is a Victorian house called 'Hope Villa'. When I recently met up with Katie and her family again after the best part of twenty years, I asked where the name came from. Her mum told me that they had heard that it was formerly overspill accommodation used by guests to the hydros, who were full of 'hope' that they would recover.

The modus operandi varies depending on who you listen to: Bryan (1903) informs us we have to walk around the stone three times before making your wish; Anthony (1997) agrees but adds that the wish must not be for money or material gain; and other sources suggest circumnavigating the rock nine times, or leaving coins on it. Does the Wishing Stone actually work, though? On my first visit to it I dutifully made a wish, which was to one day have my own local history book published. Well, there you have it; be careful what you wish for.

The Wishing Stone, Lumsdale.

Bibliography

Anon., *Famous Derbyshire Health Resorts: The Matlocks and Bakewell* (Brighton: J. S. Rochard, 1893)

Anthony, Wayne, *Haunted Derbyshire and the Peak District* (Derby: Breedon Books, 1997)

Arkle, M. J., *'Tuppence Up, Penny Down': Old Matlock Remembered in Words & Pictures* (Matlock: M. J. Arkle, 1983)

Barton, David A., *Around Matlock in Old Photos* (Stroud: Alan Sutton, 1993)

Bryan, Benjamin, *Matlock, Manor & Parish* (London: Bemrose & Sons, 1903)

Bunting, Julie, *Images of England: Matlock and Matlock Bath* (Stroud: Tempus, 2002)

Clarke, David, *Supernatural Peak District* (London: Robert Hale, 2000)

Coleman, Stanley Jackson, *Treasury of Folklore 32: Legendary Lore of Derbyshire* (Douglas (Isle of Man: Folklore Academy, 1954)

Doxey, Hubert, *A Way of Life* (Wirksworth: Hubert Doxey, 1997)

Drury, Jim, *'Fetch the juicy jam!' & other memories of Birchover* (Birchover: Birchover Reading Room, 2001)

Farey, John, *General View of the Agriculture of Derbyshire* Volume III (London: B. McMillan, 1817)

Gilchrist, R. Murray, *The Peak District* (London: Blackie, 1911)

Hackett, Richard R., *Wirksworth and Five Miles Round* (Wirksworth: J. Buckley, 1863)

Haywood, Barbara, *A Rake Through the Past: (Memories of Middleton by Wirksworth)* (Cromford: Barbara Haywood, 1996)

Kay, Barry, *Matlock Golf Club 1906–2006: 100 Years Of Golf In Cuckoostone Dale* (Little: Longstone: Country Books/Ashridge Press, 2006)

Lawrence, D. H., *Lady Chatterley's Lover* (London: Penguin, 2011)

Lawrence, D. H. (ed. Boulton, James T. & Robertson, Andrew), *The Letters of D. H. Lawrence Vol. 3, October 1916–June 1921* (Cambridge: Cambridge University Press, 1984)

Lawrence, D. H. (ed. Boulton, James T. & Vasey, Lindeth), *The Letters of D. H. Lawrence Vol. 5, March 1924–March 1927* (Cambridge: Cambridge University Press, 1989)

Lawrence, D. H., *The Virgin and the Gipsy* (Harmondsworth: Penguin, 1970)

Mallon, David, Alston, Debbie, Whiteley, Derek, *The Mammals of Derbyshire* (Chesterfield: Derbyshire Mammal Group / Sorby Natural History Society, 2012)

Naylor, Peter, *Ancient Wells and Springs of Derbyshire* (Cromford: Scarthin, 1983)

Naylor, Peter, *A History of the Matlocks* (Ashbourne: Landmark Publishing, 2003)

Pentecost, Allan, *The Thermal Springs of Matlock Bath, their History & Properties: with an Account of the Matlock Petrifying Wells* (The spa handbook series No. 3) (London: King's College (Pentecost), 2000)

Porteous, Crichton, *The Ancient Customs of Derbyshire* (Derby: Derbyshire Countryside Ltd, 1960)

Porteous, Crichton, *Toad Hole* (London: Robert Hale, 1960)

Rhodes, *Ebenezer, Peak Scenery: or, The Derbyshire Tourist* (London: Longman, 1824)

Ross, Cathy with Bennett, Oliver, *Designing Utopia: John Hargrave and the Kibbo Kift* (London: Philip Wilson Publishers, 2015)

Russell, Ian, *The Derbyshire Book of Village Carols* (Sheffield: Village Carols, 2012)

Shelley, Mary Wollstonecraft, *Frankenstein* (London: Penguin, 2012)

Taylor, Edith, *Memories of Middleton (By Wirksworth)* (Middleton-by-Wirksworth: Edith Taylor, 1996)

Taylor, Keith, *Tansley Remembered: Aspects of Village Life through Peace and War* (Little Longstone: Ashridge Press/Country Books, 2005)

Thacker, Rosemary, *The Gem of England: a Time-traveller's Guide to visiting the Matlocks* (Little Longstone: Country Books/Ashridge Press, 2015)

Tongue, Ruth, *Forgotten Folk Tales of the English Counties* (London: Routledge & Kegan Paul, 1970)

Uttley, Alison (ed. Judd, Denis), *The Private Diaries of Alison Uttley* (Barnsley: Remember When, 2009)

Waugh, Evelyn (ed. Davie, Michael), *The Diaries of Evelyn Waugh.* (London: Weidenfeld and Nicolson, 1976)

Bond, Mick, 'The Virgin & The Gypsy', *Peak Express* Issue 7 (Autumn 2005) p. 46–48

Bond, Mick, 'Further Information on the Making of The Virgin and the Gypsy', *Peak Express* Issue 11 Autumn 2006 p. 38–39

Gosling, Ray, 'Trogs at Matlock', *Nottingham Quarterly* Number 3 (Sept-Oct 1978), p. 12-15

Innes-Smith, Betsy, '"...like Ovid in Thrace" - D.H. Lawrence at Middleton-by-Wirksworth', *Derbyshire Life* Vol. 43 No. 6 (June 1978), p. 40-41

Jones, John, 'The Big Hole of Starkholmes', *Mercian Geologist* Vol. 17 Part 1 (August 2008), p. 19–22

Paulson, Ernest, 'The Matlock Monster: A Derbyshire Folk Tale', *Derbyshire Miscellany* Vol. 2 Part 2 (Autumn 1980), p. 48

Anon., 'Odd Things From Everywhere', *The King*, March 3rd 1900, p. 276

Local newspapers as cited in text

Lester, Geoff, 'How Winster got its Water' (talk to Winster Local History Group 28 April 2008)

Matlock Modern School Prospectus

Hopton-Wood Stone: A Book for the Architect and Craftsman (Whitehall: The Hopton-wood Stone Firms Limited, 1947)

'Matlock Christmas Annual' Volume 2 (Matlock: Matlock Mercury Ltd., 1949)

University of Sheffield Special Collections:

97-015, Dave Bathe Collection of Derbyshire Traditional Dance and Drama

ACT/97-003, Charlotte Norman Derbyshire well-dressing collection

University of Nottingham Manuscripts and Special Collections:
La R 10/2, D. H. Lawrence Collection: Research papers concerning Mountain Cottage, Middleton-by-Wirksworth, Derbyshire
Derbyshire Record Office:
D310, Three photographs, Two Dales, painted with Boer War characters
D2565, James Smith & Son, Nurserymen, Darley Dale
D4775, Papers of Ernest Paulson
D6550, Crichton Porteous Collection
FILE 920 HIG, Higton, Harry, Transcript of oral history interview
Derbyshire Dales District Council Planning Files:
0897/0498 | Erection of foodstore, petrol filling station, car parks, bus station, relief road and river bridge (outline) | Cawdor Quarry Matlock Derbyshire

Dead Man's Shoes, dir. Shane Meadows (2004)
The Virgin and the Gypsy, dir. Christopher Miles (1970)
Women In Love, dir. Ken Russell (1969)

https://www.facebook.com/groups/baggysbus/ - Old Matlock pics Facebook group
https://www.facebook.com/groups/292584041080640/ - Darley Dale - Past and Present Facebook group
http://www.derbyshireheritage.co.uk
http://www.welldressing.com
https://www.sheffieldforum.co.uk/showthread.php?t=541211
https://www.matlockmercury.co.uk/news/three-make-a-thrilling-find-1-859205
http://www.bbc.co.uk/history/domesday/dblock/GB-420000-360000/page/14 https://collection.sciencemuseum.org.uk/objects/co61836/
http://www.peakdistrictonline.co.uk/wensley-c10052.html
https://www.facebook.com/StalybridgeTown/
https://www.zoopla.co.uk/property-history/yew-tree-cottage/wheatley-road/two-dales/matlock/de4-2ff/32960748
http://stgilesmatlock.co.uk/
https://www.matlockmercury.co.uk/news/big-cat-confronts-matlock-cyclist-1-875766
https://pubheritage.camra.org.uk/pubs/historic-pub-interior-entry.asp?NatPubID=MAT/2217
https://www.independent.co.uk/news/obituaries/alfred-gregory-official-photographer-on-the-1953-everest-expedition-1894230.html
https://en.wikipedia.org/wiki/Joyce_Reason
http://www.saintjosephsschool-matlock.co.uk/forest-school/
https://www.amazon.co.uk/HAND-THAT-DROVE-NAILS-FLETCHER/dp/1868528855
http://www.scarthinbooks.com/authors-shakers/the-d-h-lawrence-gossip-column/
http://www.ukfossils.co.uk

Acknowledgements

Thanks to David Barrie, Paul Beattie, Christopher Booth, Tim Brooke-Taylor, Richard Bryant, Father Mark Crowther-Alwyn, Richard Dabb, Father John Drackley, Mick Eyre, Jonathan Francis, Denys Gaskell, Michael Greatorex, Roger Hardy, Joy Hayles, Canon Martin Hulbert, Katie Hunter and the Furness clan, Chris Knightly, Geoff Lester, Sarah Owers, The Peak District Lead Mining Museum, Professor Matthew Reason, John Roper, Dr Cathy Ross, Keith Taylor, and Colonel Dennis Walton.

Also thanks to the staff of Matlock Library, Chesterfield Library, the Derbyshire Record Office, Derby Local Studies Library, University of Sheffield Library Special Collections, University of Nottingham Special Collections and Manuscripts.

Thanks to Mum, Kate, Oscar, Leo, the Bradleys, Randersons, Kings, Hagues, Marples and Galloways. Extra special thanks to Dad for driving me around the area to get the photos and additional proofreading (sorry the Rutherford-Benn chamber pot murder hit the cutting room floor).

At Amberley Publishing, thanks to Marcus Pennington, Nick Grant, Nikki Embery, Philip Dean, Jenny Stephens, and Jonathan Heath.

All photos taken by the author or from author's collection unless otherwise stated.